IMAGES
of America

NEWBURYPORT

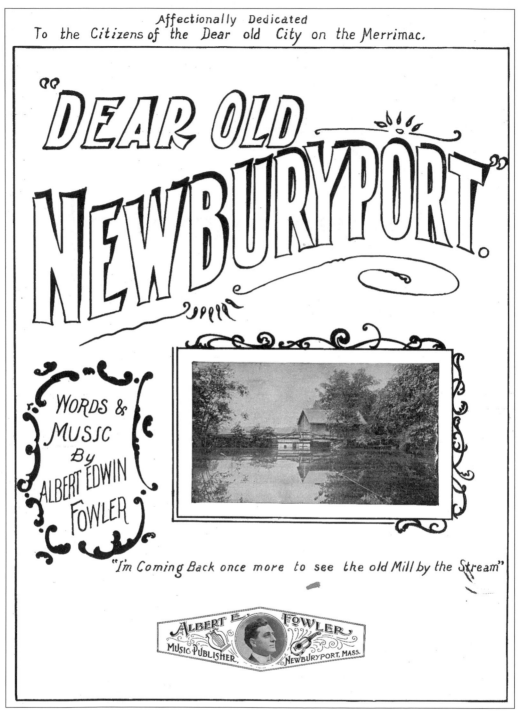

"DEAR OLD NEWBURYPORT" 1908 SHEET MUSIC.

On the Cover: WATERFRONT VIEW LOOKING TOWARD THE NEWBURYPORT/SALISBURY BRIDGE (1882 PHOTOGRAPH). (COURTESY SCOTT NASON.)

IMAGES
of America

NEWBURYPORT

John Hardy Wright

ARCADIA

Published by Arcadia Publishing,
an imprint of Tempus Publishing, Inc.
2 Cumberland Street
Charleston, SC 29401

Printed in Great Britain.

Library of Congress Catalog Card Number: Applied for.

For all general information contact Arcadia Publishing at:
Telephone 843-853-2070
Fax 843-853-0044
E-Mail arcadia@charleston.net

For customer service and orders:
Toll-Free 1-888-313-BOOK

Visit us on the internet at http://www.arcadiaimages.com

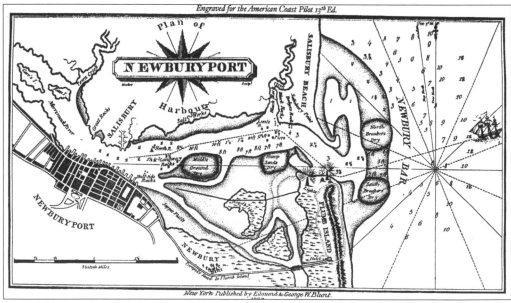

PLAN OF NEWBURYPORT HARBOR (1806 MAP ENGRAVED BY WILLIAM HOOKER; IN 1837
EDITION OF THE AMERICAN COAST PILOT PUBLISHED BY EDMUND AND GEORGE W. BLUNT).
The length ⅝(1.77 miles) and width of the Merrimack River as it flows swiftly past several
smallish islands, the city of Newburyport, Newbury, and Plum Island has been the lifeblood of
this area during previous centuries of active shipbuilding, worldwide commerce, and yachting.
Today, whale watching, narrated ocean excursions, and pleasure vessels ply the river. John
Mead Howells aptly chose *The Architectural Heritage of the Merrimack* as the title for his 1941
pictorial survey of significant dwellings from the Colonial and Federal periods, several of which
are illustrated herein. (Courtesy Daniel R. McDougall.)

CONTENTS

ACKNOWLEDGMENTS

Many special people in Newbury and Newburyport, whom the author has met and come to know over the past 15 years, and other kind souls were most helpful in the production of this pictorial history.

Gregory H. Laing, special collections librarian at the Haverhill Public Library, and Scott Nason, a period antiques dealer in Newburyport, are certainly the most important contributors to this book, with the generous loans of important images and ephemera from their archives, supplemented by insightful tidbits of local lore and legend.

Other notable individuals to be thanked are the following: Mercedes Ames, Leslie E. and Mae W. Atkinson, Clifford Bonney, Ruth Burke, Richard Canepa, Stephen Cashman, Robert Chouinard, Helen Awdey Cole, Raymond F. and Hilda D. Hartnett, Marilyn Hershfield, Perry Hopf, Paul Jancewicz, Stanley Jancewicz, Ellie Kaiser, Arthur Kellogg, Frank V. Kulik, Sally B. Lavery, Brownie Macintosh, Arnold M. Marookian, Stephanie G. McDonough, Daniel R. McDougall, Bryan McMullin, Mary Molocko, Frank Forrest Morrill, Stephen J. Schier, J. Richard Schneider, Larissa Schumann, Ronald N. Tagney, Michael and Peggy Taranda, Martha H. Tilton, William Varrell, Lisa Tagney Whitney, Vincent L. Wood, Bertha S. Woodman, and Ruth Yesair.

Individuals associated with institutions or owning businesses who are deserving of credit for their help are as follows: Nancy Carlisle, curator of collections, and Maggie Redfern, site administrator, Spencer-Peirce-Little House, Society for the Preservation of New England Antiquities; Stephen M. Haydock, outdoor recreation planner, Parker River National Wildlife Refuge; Dorothy LaFrance, director, Newburyport Public Library; Sandra Lepore, Lepore Fine Arts; Richard W. Symmes, curator and cofounder of the Laurence Breed Walker Transportation Collection, Beverly Historical Society & Museum; and Jay Williamson, curator, Historical Society of Old Newbury.

Finally, many thanks to the following friends for reading a pertinent chapter or the entire manuscript: Gregory H. Laing; Wilhelmina V. Lunt; Byron J. Matthews; Mark Sammons, executive director, and Jack L. Farrell, education director, Custom House Maritime Museum; and Nancy V. Weare.

INTRODUCTION

Situated along the mighty Merrimack River in northern Essex County, Massachusetts, the city of Newburyport has been blessed with a superb location; elegant Federal-period dwellings, many with attractive gardens, on and around High Street; architecturally pleasing commercial structures on lower State Street and in Market Square; and a noteworthy maritime heritage of more than 250 years. In 1854, three years after the waterside town became a city, Mrs. E. Vale Smith wrote in her *History of Newburyport* that it is "noted for its cleanliness, the general appearance of thrift and comfort among its inhabitants, and the number and beauty of the [elm] trees which adorn the streets . . . while the [Merrimack] river, lying at its feet, gives to it that vitality and spirit which characterize a seaport town."

Newburyport was originally part of Newbury "Old Town," which had been founded and named in 1635 by English livestock investors, who with their families had established a cattle and agricultural plantation along the Quascacunquen (later Parker) River. Evolving societal and political reasons prompted the people who resided and worked along the Merrimack to petition the Massachusetts General Court to break away and be separate from "Old Town" (the First Parish), which was effected on January 28, 1764. Until quite recently, Newburyport was the most densely populated city in the Commonwealth.

Through the late 19th century, the shoreline along the Merrimack River was dotted with shipyards, wherein builders, blacksmiths, caulkers, mast makers, riggers, and sail makers worked on a multitude of different sized vessels, initially for the British market before the Revolutionary War. Newbury-built ships traveled to distant ports and brought back valuable commodities, which enabled their owners and investors to build those spacious mansions, roughly between 1785 and 1815. The town's golden age preceded the War of 1812, after which the local economy slumped. The downturn came mainly as the result of three factors: the shipping business began drifting to ports whose harbors could accommodate larger vessels; the fortunes of many entrepreneurs were diminished by the naval embargo which began in 1807; and the Great Fire of 1811 which leveled the downtown retail area.

The infusion of new blood in the form of Irish, Eastern European, and French Canadian work-hungry immigrants, beginning during the mid-19th century for the first group and the late 19th and early 20th centuries for the latter groups, began to give the Yankee city an international flavor in the workplace and in social institutions. These new arrivals tended to congregate in the wards along the waterfront near their homes, whereas the descendants of the First Settlers maintained their residences on stately High Street, with its elaborate wooden and

cast-iron fences.

Three industries which dominated Newburyport throughout the 19th century were comb, textile, and shoemaking. Combmaking reached its apex in the 1860s and continued until the 1920s. Four large brick textile mills flourished until the 1930s when the industry left for the Southern states. Shoe manufacturing survived the longest with several factories continuing into the 1960s. By 1880, silver manufacturing was established, becoming a major industry for well over 100 years. Shoemaking, which began as a cottage industry in "ten-footers" (small shoemaking shops), loomed the largest of all until about the same time as the textile business became unraveled.

By the 1960s, the once thriving Market Square area had become a depressing, forlorn jumble of unused and unappreciated structures. Although the Newburyport Redevelopment Authority had been formed in 1960, it was not until 1968 that a thoughtful plan of restoration, not demolition, was approved by the city council. Now a well-recognized model for sympathetic urban renewal, Newburyport is a shining example of wise architectural restoration.

Visitors today are charmed by Newburyport's shops, restaurants, and educational and entertainment offerings. Those who also enjoy the beach or pursuing a finely feathered friend with binoculars can do so at Plum Island in Newbury, which features miles of beautiful beachfront, timeless dunes, and the Parker River National Wildlife Refuge.

Author's notes: Plentiful photographs and ephemera made the selection of images difficult for this all-pictorial history. Those in the Up-Along and Down-Along chapters relate to the streets to the right or left sides of State Street respectively, which has been an unofficial demarcation line used by locals for generations; they are arranged alphabetically and then numerically. Waterfront scenes are arranged in geographical sequence, for the most part, from Joppa Flats to the picturesque Chain Bridge. Chapters on Newbury and Plum Island are included, as they are within the general focus of this book.

CITY SEAL.

One
NEWBURY OLD TOWN

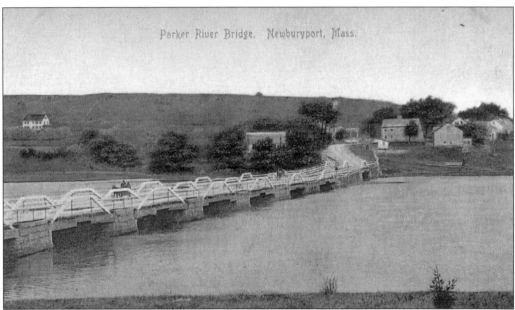

Parker River Bridge. Newburyport, Mass.

PARKER RIVER BRIDGE, HIGH ROAD (EARLY-20TH-CENTURY POSTCARD BY UNIDENTIFIED SL & COMPANY). The Parker River, named for Rev. Thomas Parker, the town's first minister, flows through Newbury around Plum Island and into the Atlantic Ocean. Shipbuilder Ralph Cross constructed the first bridge over the river in 1758, with the assistance of lottery funds. The Woodwells, who were also shipbuilders, built a replacement bridge in 1827, and others have been erected since. Less than a mile south of the bridge is the Rowley-Newbury town line, and at the other end of the bridge is a slate gravestone-shaped marker stabilized in concrete, which refers to the distance there being "4 Miles to Newbury port." Old Town Hill, on the left, rising 168 feet above sea level, offers a splendid vista of the area. The so-called Ferry House is located near the left end of the bridge. The *c.* 1715 Dole-Little House, owned by the Society for the Preservation of New England Antiquities (hereinafter referred to as SPNEA), is at the bend of the slightly curved road.

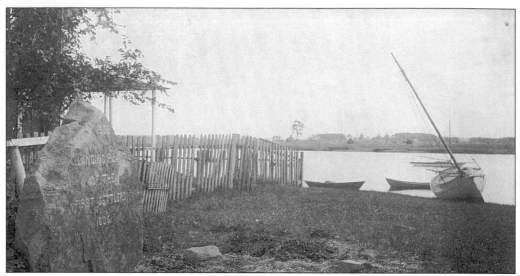

LANDING PLACE OF THE FIRST SETTLERS, END OF COTTAGE ROAD (C. 1905 PHOTOGRAPH). A roughly hewn boulder, adjacent to a modest boat ramp, was dedicated in 1902 with many proud descendants present. Edith Wills Kelton noted on the cardboard mount below this image that "Nicholas Noyes, a youth of 19, was the first to leap ashore. From him my mother & father were both descended. He was a brother of the minister Rev. James Noyes." Many salt marsh haystacks on the opposite shore echo the shape of the boulder. (Courtesy Gregory H. Laing.)

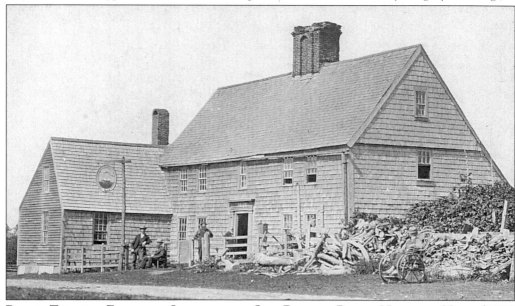

POORE TAVERN, FORMERLY LOCATED ON OLD ROWLEY ROAD, NEWBURY NECK (1873 STEREO VIEW). Although many 18th- and 19th-century farmhouses still survive along and off High Road, this architecturally significant First Period dwelling, which was south of the Parker River, unfortunately does not. Granting that early construction dates can be uncertain, "1642" was painted on the door lintel. The tavern's oval trade sign was donated to the Marine Society of Newburyport sometime after 1851. Washington Adams, the donor, noted that the "Sign of second house of entertainment at Newbury was kept by Jonathan Poor, in 1776, house built in 1664." (Private collection.)

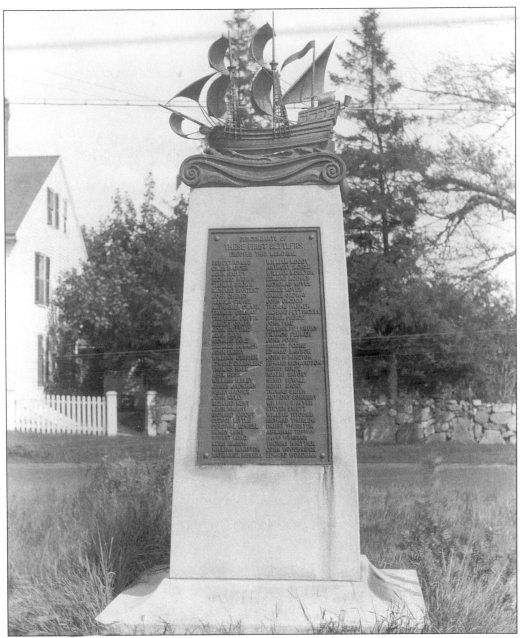

NEW MONUMENT, LOWER GREEN (C. 1910 PHOTOGRAPH). A bronze sculpture representing the *Mary and John* at full sail is at the apex of the granite pillar, along with two bronze tablets. The monument commemorates the landing and the initial community of the First Settlers in 1635. Listed on this tablet are 70 names of direct descendants who had the memorial erected in 1905. Behind the monument on the green is a one-room, two-door schoolhouse, probably attended by many of the descendants during the late 19th and early 20th century. Three-tenths of a mile along the same side of Route 1A North is the Burying Ground of the First Settlers, laid out in the founding year by the town selectmen. In 1929, when the cemetery was restored, a reproduction slate gravestone was erected in memory of Edward Woodman, one of the "planters" who arrived in the *Mary & John*.

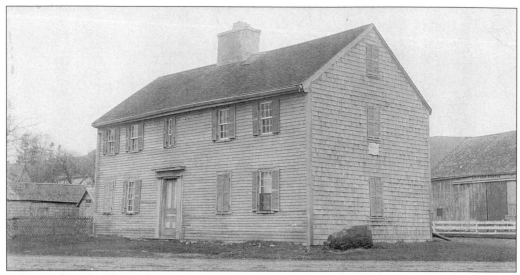

SAMUEL SEDDON HOUSE, LOWER GREEN (C. 1900 PHOTOGRAPH). The dwelling that Samuel Seddon built *c.* 1728 provided entertainment for travelers who used the Old Town ferry. The Seddon House was restored twice, the first time in 1940 after it had suffered some fire damage. In 1976, local philanthropist and nationally known horsewoman Mrs. Florence Evans Dibble Bushee bequeathed the house to SPNEA, which later sold it with certain architectural restrictions. To the right of the privately owned house is Newman Road, which leads to Old Town Hill and the Bushee estate. (Private collection.)

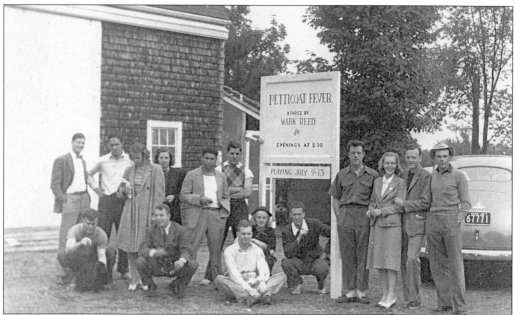

"THE THEATER," OLD TOWN FARM (1940 PHOTOGRAPH). Longing to keep busy during the summer months after they graduated from college in 1939, this group of young thespians approached local businesspeople for donations of money and materials to construct a playhouse in the barn offered to them by Mrs. Bushee. *Petticoat Fever* was one of the plays the amateur group performed, under the tutelage of a professional Boston theater director. (Courtesy Jack L. Farrell.)

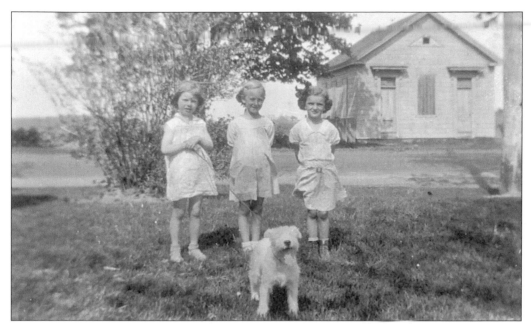

THE RIDGE SCHOOL, HEAD OF HAY STREET (C. 1927 PHOTOGRAPH). This one-room schoolhouse and others in Newbury were built so that local children could walk to school. Those who needed or chose to ride did do so on the "Bluebird," a covered vehicle that transported students between the Parker River area and the West School. Posing with their friend Betty Knight's terrier "Skippy" are, from left to right, Barbara Knapp, Louise Rolfe, and Jean Dower. (Private collection.)

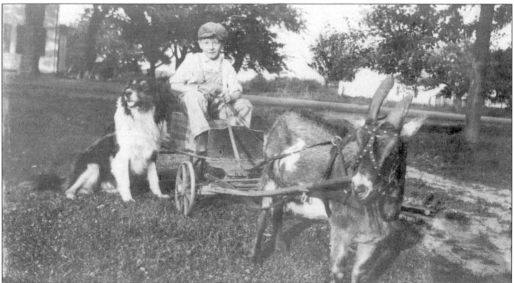

"TOOKY" AND HIS GOOD FRIENDS, 110 HIGH ROAD (C. 1924 PHOTOGRAPH). David "Tooky" Knight, one of six children of Ernest and Elizabeth K. Knight, pulls the reins in on "Jeffy" the goat while faithful "Bob," a prized sheepdog, rests at his side. First Settler John Knight and his wife Elizabeth Vincent Knight established their farm in Newbury in 1638, and it has been in operation ever since. Carmen Biello, a native of Italy, worked on the farm for about 50 years during the early 20th century. (Private collection.)

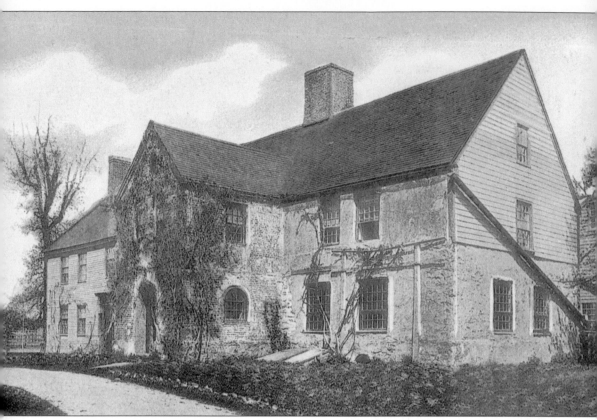

SPENCER-PEIRCE-LITTLE HOUSE, 5 LITTLE'S LANE (C. 1895 PHOTOGRAPH BY CHARLES B. WEBSTER; PRINTED IN GERMANY AS A POSTCARD FOR P.K. SANDERS OF NEWBURYPORT). Known locally as the "Stone House" and identified as the "Mansion House" on Philander Anderson's 1830 map of the greater Newburyport area, this c. 1690 brick and stone, cruciform-plan dwelling is the only 17th-century structure of its kind in existence in New England. Resembling an English manor house, it was owned initially by Col. Daniel Peirce and is now on 230 acres of the original 400-acre land grant owned by John Spencer in 1635. Different families called the unique dwelling their home, including the Tracy, Boardman, and Little families, the latter since 1861. The three Little sisters were the last owners, until 1986, when nonagenarian Amelia Little passed away, thus transferring ownership of the estate to SPNEA.

NATHANIEL TRACY (1751–1796, OIL ON CANVAS, ATTRIBUTED TO MATHER BROWN, 1785). Nathaniel Tracy, once Newburyport's most affluent citizen, secluded himself within the protective walls of the Spencer-Peirce farm after the failure of his mercantile partnership in 1785. The partnership was with brother John Tracy and associate Jonathan Jackson. (Courtesy Newburyport Public Library; gift of Miss Louisa Tracy Lee and Gen. and Mrs. William Raymond Lee.)

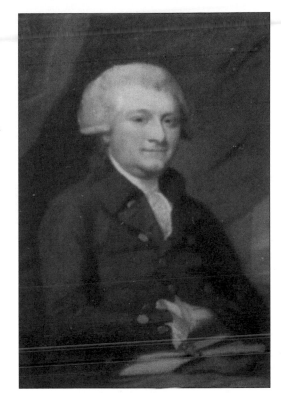

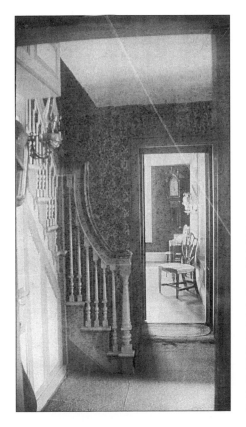

ENTRANCE HALL OF THE SPENCER-PEIRCE-LITTLE HOUSE, 5 LITTLE'S LANE (C. 1890 PHOTOGRAPH BY HIRAM P. MACINTOSH, 1830–1907). The oldest interior photograph of the dwelling shows an all-over floral wallpaper, which adds a soft touch to the bold, angular handrail, lathe-turned banisters, and newel post of the Georgian period, added onto the stairway with its fanciful stair-end detail and raised panels. In the hall are a Hepplewhite shield-back side chair made in Salem or Boston and a tall case clock attributed to Timothy Chandler of Concord, New Hampshire. (Courtesy Laing Collection.)

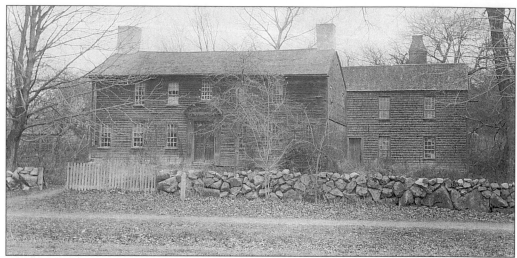

KNIGHT-SHORT HOUSE, 39 HIGH ROAD (C. 1900 PHOTOGRAPH). Abiel Somerby and his namesake son were brick makers in Newbury during the early-to-mid-18th century, and they may have supplied the bricks as well as built the end walls and chimneys of this *c.* 1717 dwelling. The original segmental-arch door pediment, with its dentils and stop-fluted pilasters in the Doric order, intrigued curators and officials at the Metropolitan Museum of Art in New York City so much that they were able to acquire the architectural element to install in the American Wing. Rolfe's Lane, at the left side of the Knight-Short House, leads to Water Street. (Private collection.)

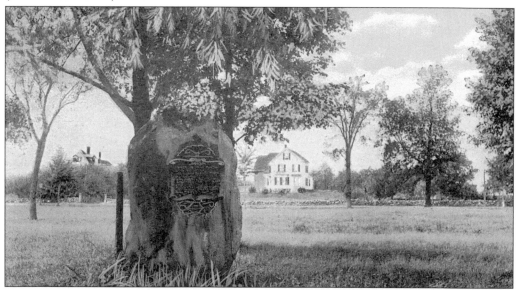

OLD STONE BRONZE TABLET, UPPER GREEN, HIGH ROAD (EARLY-20TH-CENTURY POSTCARD PUBLISHED FOR S.H. KNOX & COMPANY). Many First Settlers moved to the Upper Green *c.* 1646, and the area became a "traenying field" in 1775 during the Revolutionary War. The asymmetrical boulder has a scroll-shaped plaque with information pertaining to an encampment held nearby for three companies of riflemen who participated in the assault on Quebec with Benedict Arnold in that year. A one-room schoolhouse, known as the East School, was located near the end of the pond until it was moved to the rear of the Little-Muzzey property and remodeled into a house.

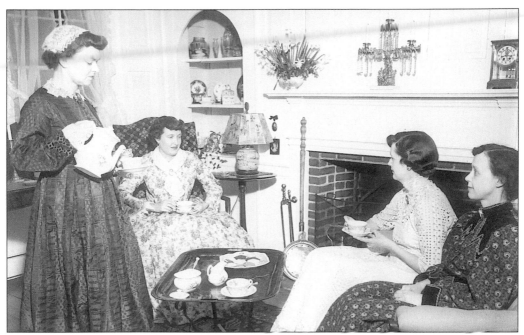

A Tea to Save the Steeple, 12 Green Street (June 5, 1954 photograph). Helen Atkinson pours a cup of tea for Ann Eldredge Little, while their cousins Sylvia (left) and Wilhelmina Lunt talk about the project to save the steeple of the nearby First Parish Church. Originally a blacksmith shop, Wilhelmina Lunt's charming home was one of several private residences and SPNEA properties on the Saturday tour featuring "Homes of Yesterday and Today in Old Newbury." (Courtesy Wilhelmina V. Lunt.)

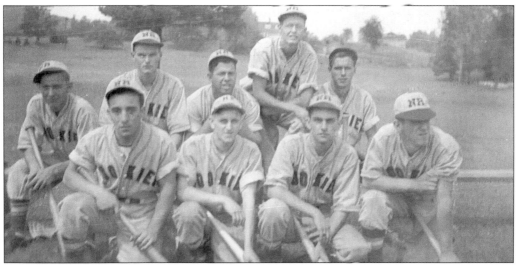

Members of the Newbury Rookie Baseball Team (c. 1947 photograph). Some of the players in Tom Lunt's baseball scrapbook, which he started in 1946, are in this casual photograph. The Rookie team was the winner of the Newburyport Twilight League that year. Pictured from left to right are (front row) Merle Ananian, John White, Charles Hopkinson, and Donald Knight; (back row) George Dupuis, Edmund Noyes, Raymond Forsythe, 1948 manager Thomas Lunt, and Douglas Woodworth. (Courtesy Lunt Collection.)

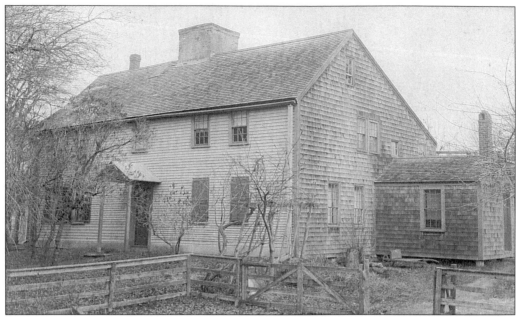

JOHN ATKINSON HOUSE, 5 HANOVER STREET (LATE-19TH-CENTURY PHOTOGRAPH). Located opposite the wide end of the Upper Green, this *c.* 1664 saltbox house is currently owned, once again, by descendants of the first owner, John Atkinson. The town fathers granted Atkinson one acre of land with the proviso that he live in Newbury and be the town hatter for seven years. John and his wife, the former Sarah Mireck, produced 11 children, and their son Nathaniel, who married Deborah Knight, had six offspring. (Private collection.)

LITTLE-MUZZEY HOUSE, 26 GREEN STREET (C. 1885 PHOTOGRAPH BY SARAH COLEMAN OF DEERFIELD). Ancient twisted poplar trees almost obscure this dwelling, which has prominent end chimneys and outbuildings. A stone wall of almost equal vintage encloses the property, with its orchard at the right. In September 1802, Rev. William Bentley of Salem noted in his *Diary* that "Yesterday was a terrible tornado at Newbury. It passed the river to Salisbury & was about 30 rods wide in its course. It destroyed Houses, Barns, Orchards, Trees, fences & every obstacle in its way. It is affirmed to have been the most violent ever known in this part of the County." (Private collection.)

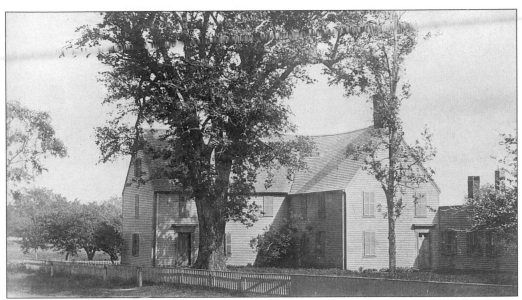

NOYES HOUSE, 7 PARKER STREET (C. 1895 PHOTOGRAPH BY GEORGE E. NOYES). Many generations of the Noyes (pronounced "Noice" or "No-yes" locally) family resided in this house until *c.* 1975. Rev. Thomas Parker and his nephew-associate Rev. James Noyes were the first owners when the dwelling was raised *c.* 1649. A charming and unusual feature is the secret room located near the large chimney (hidden by the elm tree near the back door). Both revered reverends had their small religious book published in London before 1650. (Courtesy Lunt Collection.)

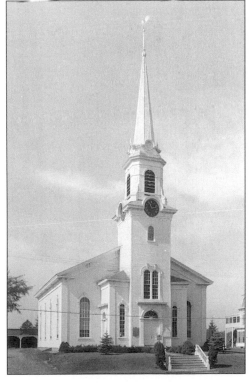

FIRST CHURCH OF NEWBURY, 20 HIGH ROAD (MID-20TH-CENTURY PHOTO CARD BY AN UNIDENTIFIED PUBLISHER). Situated on a knoll opposite the Old Town cemetery, the present structure is the fourth house of worship of the First Settlers, the previous church having been destroyed in the fire of 1868. The gilded rooster weather vane that adorned the 1806 Federal-period edifice still beckons worshipers today. (Courtesy Lunt Collection.)

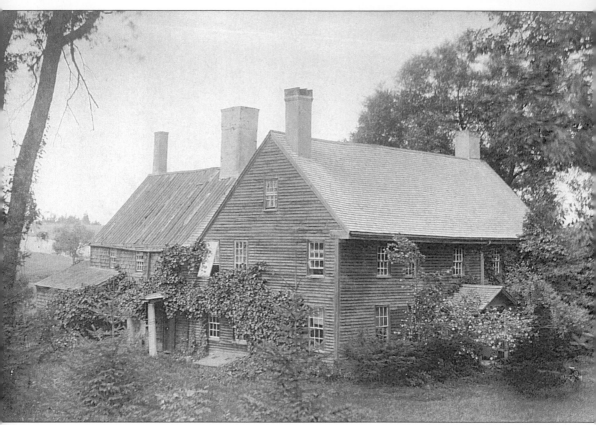

TRISTRAM COFFIN HOUSE, 16 HIGH ROAD (LATE-19TH-CENTURY PHOTOGRAPH). The *c.* 1654 Coffin House has been home to seven consecutive generations of the same family, and like "Topsy," has grown and changed to accommodate the needs of its inhabitants. A complete 18th-century buttery, located off one of the kitchens on the north (cooler) side of the dwelling, is a unique and undisturbed early feature. Tristram Coffin Jr. and Nathaniel Coffin, the first two owners, were tailors by profession when the house began life as a two-and-one-half-story, single-room structure. Joshua Coffin (1792–1864), a longtime resident, was the family antiquarian who wrote *A Sketch of the History of Newbury, Newburyport, and West Newbury* in 1845. The Tristram Coffin House is a SPNEA property.

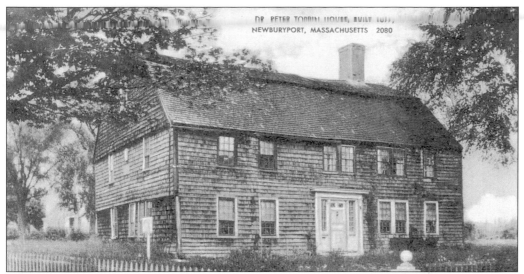

DR. PETER TOPPIN [SIC] HOUSE, 5 HIGH ROAD (EARLY-20TH-CENTURY POSTCARD PUBLISHED BY AMERICAN ART POST CARD COMPANY, BOSTON). A First-Period overhang usually appears on a pitched-roofed house, with or without a lean-to. The double overhang on this commodious gambrel-roofed dwelling, which is sited slightly kitty-corner to the road, gives it added distinction. "Yours, ma'am, if you will!" was Dr. Toppan's retort to an attractive young woman who inquired of him, "I wonder whose house that is across the road?" Needless to say, she accepted this unique proposal of marriage, and shortly thereafter they took up residence therein.

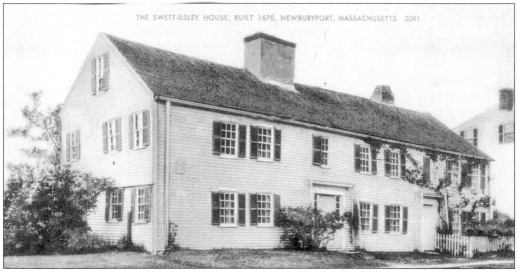

SWETT-ILSLEY HOUSE, 4 HIGH ROAD (EARLY-20TH-CENTURY POSTCARD PUBLISHED BY AMERICAN ART POST CARD COMPANY). The length of this c. 1670 two-family dwelling is in contrast to the width of the Peter Toppan House. There is a massive 10-foot-wide fireplace opening in the center portion of the house, which may have been the first ordinary, or tavern, in Newbury. Ladies and gentlemen who enjoyed one another's company while sipping tea at the former Four High Road Tea Room and architectural historians who visit the house today admire the paint-spotted ceiling as an early decorative feature. The Swett-Ilsley House is a SPNEA property.

Newburyport Turnpike (1920s postcard published by American Art Post Card Company). The Newburyport Turnpike, now called Route 1, begins at the head of State Street at the intersection of High Street. When completed in 1806, it stretched "in a direct course" of 26 miles to Malden Bridge. Maj. David Coffin of Newburyport, a shipowner and storekeeper, was one of the original investors of the proposed efficient route to Boston, which cost $420,000. Pleasant vistas near the beginning of the turnpike still include salt marshes, streams, and farms in Newbury and Rowley.

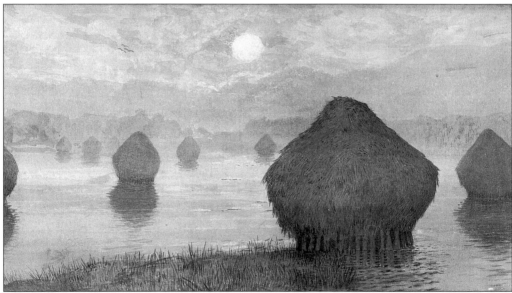

Salt Marsh Haystacks, Newbury (c. 1890 watercolor by John Worthington Mansfield, 1849–1933). The monochromatic watercolor that the Ipswich artist painted of haystacks on staddles resemble the five icons that dot the Newbury marsh on Route 1 North. An informative sign nearby states that the salt marsh is part of a "Great Marsh," extending from Cape Ann into New Hampshire. The incoming tide floods the low marsh with its low salt marsh grass (Spartina alterniflora) twice per day, and the high marsh with its high salt marsh grass (Spartina patens) is flooded sporadically. (Courtesy Edward Leaman.)

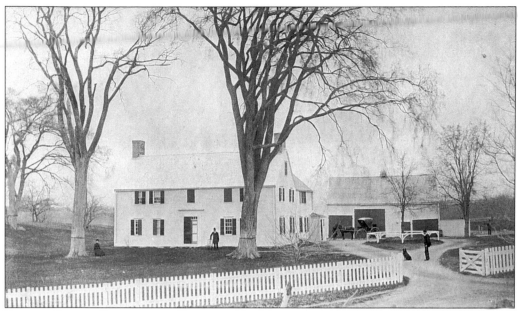

BYFIELD PARISH PARSONAGE, FORMERLY LOCATED AT 148 ELM STREET, BYFIELD (LATE-19TH-CENTURY PHOTOGRAPH). Girdled trees flank the *c.* 1703 dwelling built for Rev. Moses Hale, which had opened and closed window shutters when this picture was taken. The elderly gentleman standing next to the Chippendale side chair is possibly the Reverend Wittington. An interesting wooden fence conforms to the roundabout in front of the stable. (Private collection.)

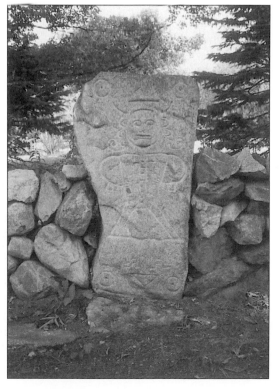

"WITCHSTONE FARM" BOUNDARY MARKER, COLEMAN ROAD, BYFIELD. This fascinating carved diorite boundary marker is an integral part of the stone wall on the farmstead that Richard Dummer owned at Newbury Falls in the Byfield Parish section of Newbury. Carved by an unidentified stonecutter *c.* 1660, the stick figure wears 17th-century-style apparel and might be a witch hex symbol, a representation of Dummer or another local personage, or perhaps the newly crowned King Charles II.

OLD SMITHY AT THE FALLS, 43 MAIN STREET, BYFIELD (C. 1895 PHOTOGRAPH). Something in the gently flowing stream or perhaps the broadside on the tree has caught the attention of the young man. Until 1794, most nails were made by the village blacksmith; but after a nail-cutting machine was invented by Jacob Perkins of Newburyport in that year, rose-head nails passed out of fashion. Water to power early gristmills and sawmills in Newbury flowed over the falls at Central Street in Byfield. The Byfield Woolen Factory had the distinction of being the first textile mill to operate in Massachusetts, from 1794 to 1932, when it was destroyed by fire. (Private collection.)

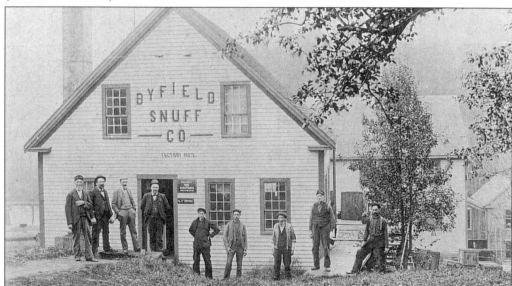

BYFIELD SNUFF COMPANY, FORMERLY LOCATED ON LARKIN ROAD, BYFIELD (1900 PHOTOGRAPH). A former sawmill became part of the factory that began producing the powdered tobacco inhalant *c.* 1890. Standing in front of factory no. 2 are, from left to right, Elijah Searles; Benjamin Pearson Jr., vice president and manager; Howard Morrill; George Choate, salesman; Dan Johnson; Arthur L. Hale; James Thompson; G. Dole; and Ellsworth Kent. (Courtesy *Images from the Past*, Newbury Historical Commission.)

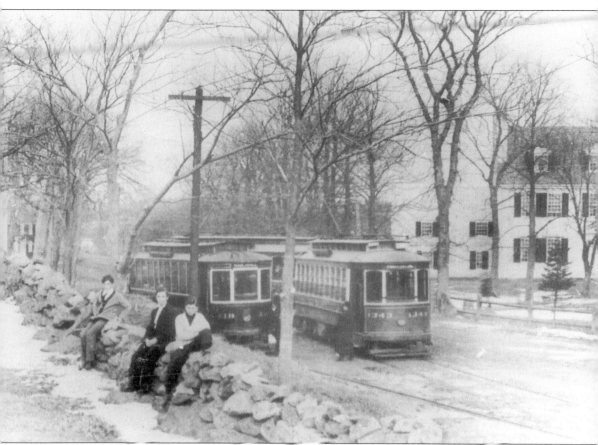

BOYS AND TROLLEYS, ELM STREET, GOVERNOR DUMMER ACADEMY, BYFIELD (C. 1915 PHOTOGRAPH). Three academy students perch on a stone wall opposite the headmaster's house during the start of the school year. This location was an important transfer point for electric cars serving residents in Essex, Gloucester, Groveland, Haverhill, and Newburyport. In existence between 1887 and 1904, the Newburyport Car Manufacturing Company made trolleys mainly for New England railways. Not included in the photograph are the 1708 milestone at the corner of Elm Street that is carved with the mileage to Boston of 33 miles and to Newbury of 5 miles, and the boulder on the traffic island near the boys that bears a bronze plaque dedicated to the "Sons of Newbury Who Bore Arms in the World War, 1914–1918." (Courtesy Walker Transportation Collection, Beverly Historical Society & Museum.)

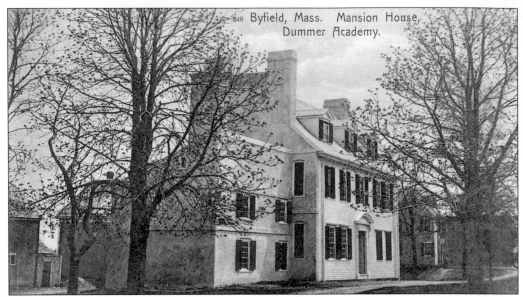

MANSION HOUSE, DUMMER ACADEMY, ELM STREET, BYFIELD (C. 1910 POSTCARD PUBLISHED BY THE LEIGHTON COMPANY). The brick-end mansion house was built in 1730 for Lt. Gov. William Dummer (1677–1761) on the 1,080-acre grant of land that William's father, Richard Dummer, had received as a First Settler. The mansion has been the headmaster's house of Governor Dummer Academy since the school's founding in 1763. On a sign located at the beginning of Middle Road are that date, in a chevron, and the school's crest—a shield with a rampant lion above two fleur-de-lis. Nearby is the original schoolhouse, which was built in that year and reconstructed in 1938. Now co-educational, Governor Dummer Academy is still the oldest, private boarding school in America. (Courtesy Lunt Collection.)

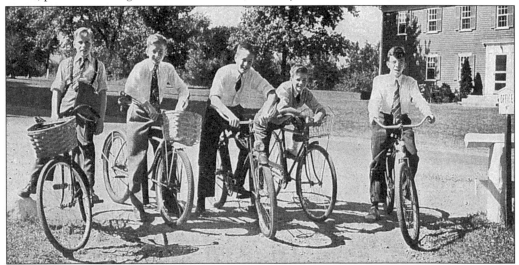

IN BETWEEN CLASSES, GOVERNOR DUMMER ACADEMY (1944 PHOTOGRAPH). Five cheerful friends on bicycles, who are probably first-year students at the private boys' school, were lucky to have this picture included in *The Milestone*, the yearbook presented by the senior class. Several individual photographs of different sports team members show them standing by the 1708 Newbury-Boston milestone. Edward Williams Eames was the headmaster in 1944, and Remington Alonzo Clark Jr. of Winchester was the class president. (Courtesy Lunt Collection.)

Two

PLUM ISLAND

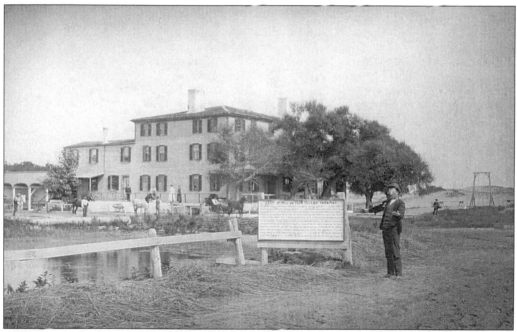

"WELCOME TO THE PLUM ISLAND HOTEL," CORNER OF OLD POINT ROAD AND THE PLUM ISLAND TURNPIKE (PRE-1886 PHOTOGRAPH). "A fantastic strip of sand," Plum Island runs north and south, between 8 and 9 miles in length, and is less than a mile wide. Human, animal, and bird populations coexist on the scenic island—people like to live in cottages and houses to the left and right where the turnpike ends; deer, foxes, and birds prefer to inhabit wooded and swampy areas in the Parker River National Wildlife Refuge. Built in 1806, the Plum Island Hotel, as well as its enlarged and renovated reincarnation (see p. 32), was well-visited by the carriage trade during the summer season. (Private collection.)

OLD PLUM ISLAND BRIDGE (C. 1880 PHOTOGRAPH BY SELWYN C. REED). The mid-19th century wooden bridge has a rambling appearance as it traverses the Plum Island River with Newburyport in the distance. Incorporated in 1805, the Plum Island Turnpike Company was responsible for the roadway, which runs southeasterly from Water Street to the island, and the bridge which connects the island to Newbury. The first bridge was washed away in 1832, and the second one disappeared in 1851; it was known by locals as Plum Bush Bridge during the mid-19th century. (Courtesy Laing Collection.)

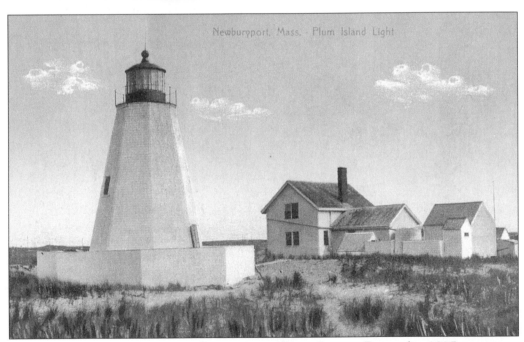

PLUM ISLAND LIGHT, FORMERLY LOCATED ON PLUM ISLAND POINT (C. 1895 POSTCARD PUBLISHED BY THE LEIGHTON COMPANY). Built in 1789, this octagonal, shingled-sheathed, always white-painted lighthouse served as a beacon of safety for 109 years until it was razed in 1898, or shortly thereafter. In 1795, Rev. Dr. William Bentley of Salem noted, "From Newbury we learn that they have shifted their lights on the end of Plum Island, so that the lights abreast might bring a vessel over the [sand]bar, by shewing [sic] the true course."

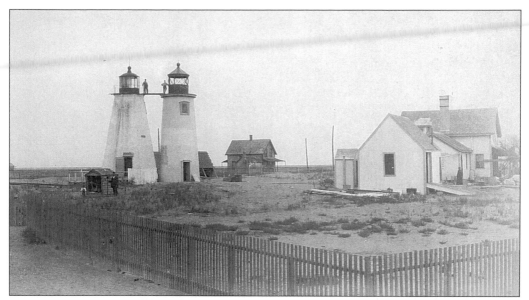

PLUM ISLAND LIGHTHOUSES, END OF NORTHERN BOULEVARD ON PLUM ISLAND POINT (1898 PHOTOGRAPH). Two men pose on the connecting catwalk the year the new structure was completed. The lighthouse keeper's cottage with additions had been built earlier. In 1808, a whirlwind wreaked havoc on this end of the island, tossing over the two previous lighthouses in opposing directions, as noted in Reverend Bentley's *Diary*. (Courtesy Nason Collection.)

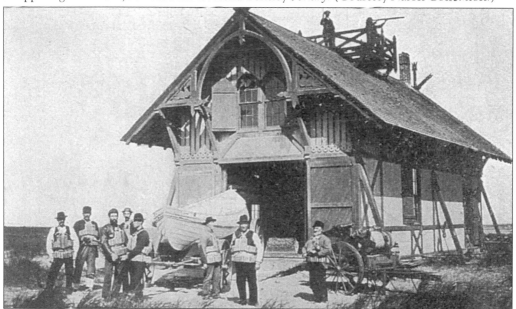

LIFESAVING STATION, HIGH SANDY BEACH (C. 1890 PHOTOGRAPH). Built by William Dodge and John Kilburn in 1874 on the Atlantic Ocean side of the island, opposite the beginning of what later became the Parker River National Wildlife Refuge, this picturesque structure was moved northward in 1881 to its new location closer to the Merrimack River. Two 19th-century keepers of the lifesaving station were Robert Floyd and James Elcott. The Washington Light Guards, a local and colorful militia unit, was stationed at Plum Island during the War of 1812, "where they maintained regular camp exercises" to protect Newburyport.

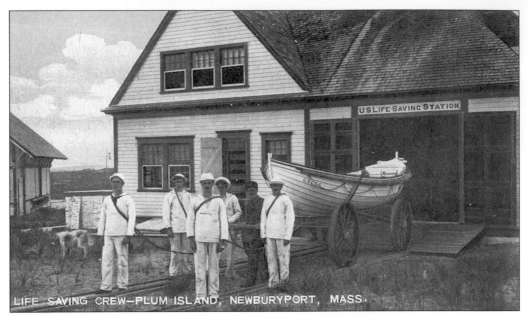

LIFE SAVING CREW—PLUM ISLAND, NEWBURYPORT, MASS.

LIFESAVING CREW, MERRIMACK RIVER LIFESAVING STATION, FORMERLY LOCATED AT THE END OF 45TH STREET (C. 1908 POSTCARD PUBLISHED BY THE LEIGHTON COMPANY). When the new station house was built in 1890, the former structure, partially visible at the left, became the boathouse. Capt. Thomas J. Maddock, who was born in North Scituate, commanded the volunteer crew between 1897 and 1919. Dauntless members of the lifesaving crew were "Always Ready" (*Semper Paratus*), realizing that "You gotta go but you don't have to come back!" Faithful and brave Saint Bernard dogs were the most popular breed at lifesaving stations.

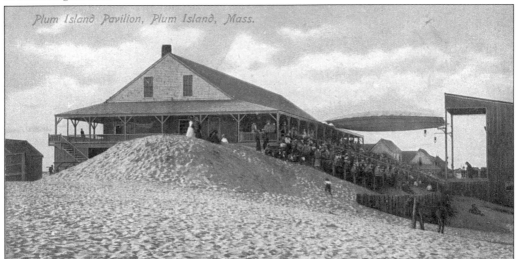

Plum Island Pavilion, Plum Island, Mass.

"PLUM ISLAND PAVILION" (C. 1908 POSTCARD). After petting the brown horse, or pony, tied to a post, a young boy scrambles up the sand dune to join family members seated on the bleachers in front of the outdoor theater. Plays, band concerts, and dancing drew large and enthusiastic crowds until 1913 when the shingled Pavilion with its wraparound porch was destroyed in an afternoon fire on July 9. That evening another fire damaged half of the wooden bridge connecting the island to Newbury.

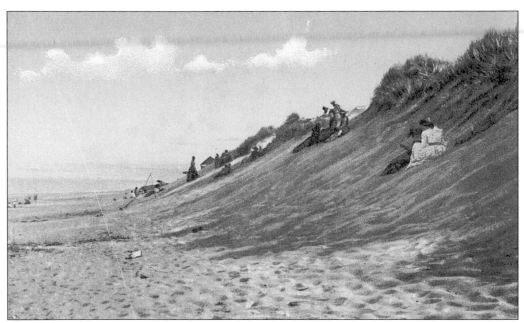

SAND DUNES (C. 1895 POSTCARD PUBLISHED BY THE LEIGHTON COMPANY). In 1649, the General Court of Massachusetts divided Plum Island, allocating two-fifths each to Ipswich and Newbury and one-fifth to Rowley. Mrs. E. Vale Smith, in her 1854 *History of Newburyport*, wrote that "the eye recalls the sandy beach dotted with tents; the cloth spread on the clean yellow sand, surrounded with groups of young men and maidens, old men and children, the complacent pastor and the grave deacon, all enjoying together a day of unrestrained mirth and healthful recreation."

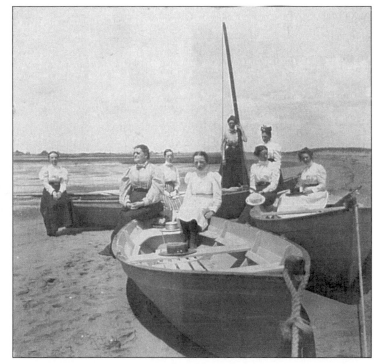

A LADIES-ONLY BOATING PARTY (C. 1896 PHOTOGRAPH). Immaculately dressed women and their youthful friend or relative stand or sit in quietude in opposing directions by the Plum Island basin. A high collar with a plain or pretty ribbon, leg-o-mutton sleeves, ankle-length skirts, and high-buttoned leather shoes were *de rigueur* for the turn-of-the-century, fashion-conscious woman. (Courtesy Nason Collection.)

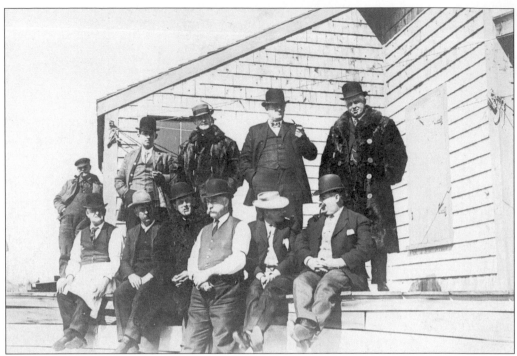

ANNUAL PRE-SPRING FARM GET-TOGETHER, PLUM ISLAND (C. 1895). This convivial group of Newbury farm owners and friends always used the same cottage each spring to revive old friendships over large bowls of steaming fish chowder, made by the gentleman wearing an apron. Ernest W. Knight is seated third from the left; Percival Stickney, a butcher, is standing behind him; and horse trader Daniel Little is at the far right, wearing a warm, full-length fur coat on the chilly afternoon. (Private collection.)

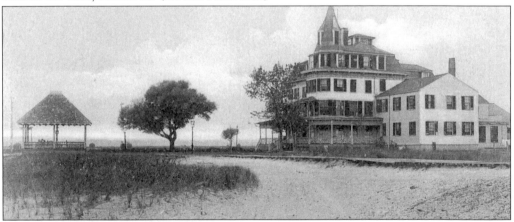

PLUM ISLAND HOTEL, CORNER OF PLUM ISLAND BOULEVARD AND OLD POINT ROAD (1905 POSTCARD PUBLISHED BY THE ROTOGRAPH COMPANY, GERMANY AND NEW YORK). Remodeled and enlarged during the Victorian period, the hotel featured a wraparound piazza, monitor roof, and fanciful tower, and was a familiar landmark on the island until it was destroyed by fire in 1914. A conflagration the previous year at the curve in the road wiped out the original dance pavilion, stores, and some cottages. The first private cottage erected on the island—a large summer home—was built on a nearby high sand dune by Michael H. Simpson in 1880. (Courtesy Lunt Collection.)

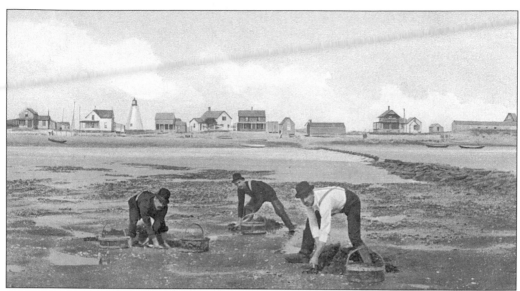

CLAM DIGGERS AT WORK, NEAR PLUM ISLAND POINT (PRE-1898 POSTCARD PUBLISHED BY THE LEIGHTON COMPANY). Clamming can be backbreaking work, and these fellows try to fill their wire and wood baskets before the incoming tide fills the basin near the dike at the right. The old lighthouse shown in the background is still there, as are most of these cottages or their replacements, but no residences were built on the land leased by the heirs of Moses Pettingill until the 1870s. By the 1920s, renters had first choice to buy land offered by the Plum Island Beach Company.

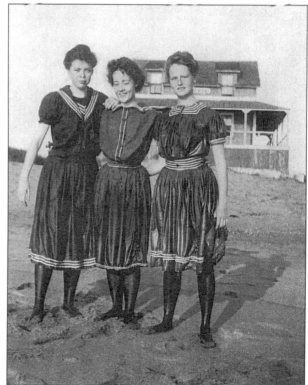

WET AND WOOLLY (C. 1910 PHOTOGRAPH). Having emerged from the ocean side of Plum Island after a dip, these friends pose in front of the Buena Vista cottage, owned by the McKinney family of Newburyport. Eliza McKinney (left), Carrie Coffin (middle), and their unidentified companion were local residents who may have taken the electric trolley to Plum Island for the day or a week's vacation. While this getaway was perfectly acceptable to their parents, honky-tonk Salisbury Beach certainly was not. (Courtesy Cynthia Noone Wildes.)

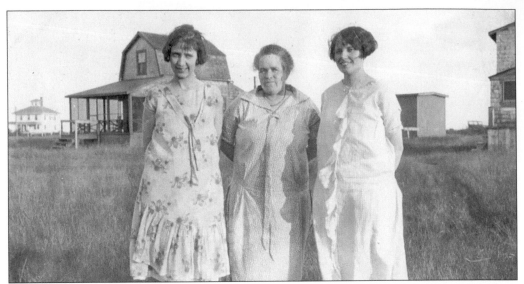

A PLUM BUSH DOWNS TRIO (1920S PHOTOGRAPH). Luxuriant marsh grass carpets these simple cottages, many of which began as gunning camps for wildfowl hunters, to the left side of Plum Island Boulevard. Standing from left to right in front of a gambrel-roofed cottage with its screened-in piazza, are Doris and Nellie Brown with an unidentified friend; the Browns resided on Prospect Street in Newburyport when not enjoying the simple life the island offered. "Seabreeze" and "Highland Cottage" were common names during the early-20th century, while creative names such as "Rinkoo-Tei" and "Wosumonk" perplexed first-time visitors. (Courtesy Stephanie G. McDonough.)

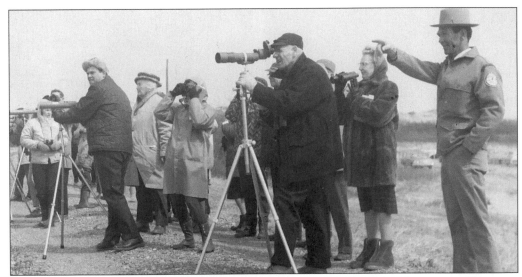

A GATHERING OF DEDICATED BIRD-WATCHERS, PARKER RIVER NATIONAL WILDLIFE REFUGE (C. 1965 PHOTOGRAPH). Established in 1942 to protect an important Atlantic flyway for migratory birds on the Massachusetts coast, the refuge provides undisturbed feeding, resting, and nesting habitat for waterfowl and shorebirds, as well as for a variety of mammals, reptiles, wildlife, and insectivorae. The refuge has a 6.3-mile road which meanders past salt pans and varying trails with access to dune paths and boardwalks through marsh wetlands. (Courtesy Parker River National Wildlife Refuge.)

Three

UP-ALONG

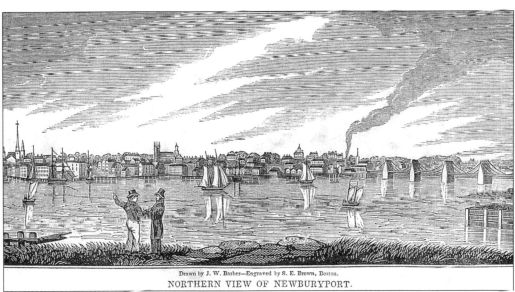

Drawn by J. W. Barber—Engraved by S. E. Brown, Boston.
NORTHERN VIEW OF NEWBURYPORT.

NORTHERN VIEW OF NEWBURYPORT (1839 WOOD ENGRAVING IN JOHN WARNER BARBER'S *HISTORICAL COLLECTIONS OF EVERY TOWN IN MASSACHUSETTS*). The observant author-artist wrote that Newburyport encompassed about 647 acres and had a population of 6,741 inhabitants in 1837. Compact in size, "it presents the aspect of a considerable city, extending to the distance of nearly three miles. A lower street, upon which the wharves and docks open, follows the course of the river; and parallel with this an upper or High street extends the whole length of the town." One of the gentlemen in the engraving is pointing to the Town Landing at the foot of State Street, as vessels sail past them on the Salisbury shore. The house on the hill with the large cupola may be "Lord" Timothy Dexter's former fabled mansion, and a sign of the Industrial Revolution to come may be seen in the smoke swirling from a factory next to the 1827 bridge, which crossed the Merrimack River.

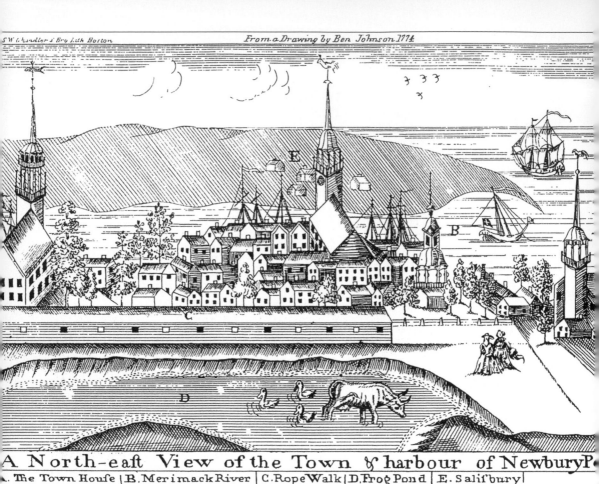

A North-east View of the Town & harbour of NewburyP•

A. The Town Houſe | B. Merimack River | C. Rope Walk | D. Frog Pond | E. Saliſbury

A NORTH-EAST VIEW OF THE TOWN & HARBOUR OF NEWBURYPORT (1854 PRINT AFTER THE 1774 ENGRAVING BY BENJAMIN JOHNSTON, 1742–1818). "Anonymous" was atop Burial Hill overlooking the Frog Pond when he sketched the earliest surviving view of the compact pre-Revolutionary town, ten years after Newburyport was separated from Newbury "Old Town." The couple at the right may have belonged to either the North Congregational Society (left), which was built in 1768; the First Parish in Newburyport (middle), built in 1725 in Market Square; or the Presbyterian Society (right), built in 1756 on Federal Street. The three houses of worship were replaced by later structures for one reason or another. Two sailing vessels round the point of land at Salisbury, originally called Colchister, with its scattered residences. Commerce with the French West Indies and other distant ports made the waterfront bustle with activity and introduced unusual goods for the inhabitants' consumption.

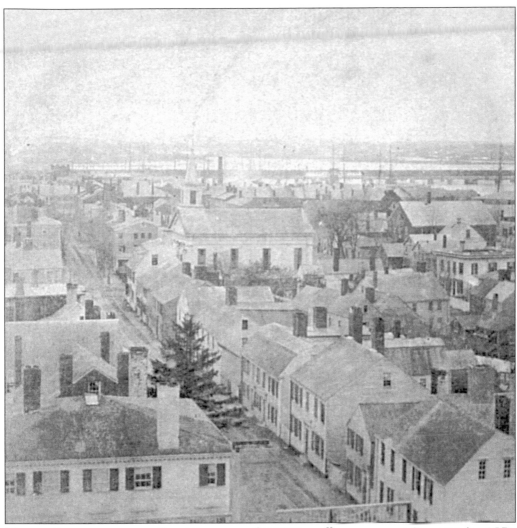

MIDDLE STREET FROM THE STEEPLE OF THE OLD SOUTH PRESBYTERIAN CHURCH (C. 1870 STEREO VIEW BY HIRAM P. MACINTOSH). Newburyport had seen no major changes in its landscape between 1839, when Dr. Henry C. Perkins took the first "solar painting," or daguerreotype, and c. 1870, when professional photographer Macintosh started to record scenes in the town. Depicted in this view is the Universalist Church on Fair Street, nestled amongst gambrel-, gable-, and hip-roofed dwellings, with the Eastern Railroad Company's bridge crossing the Merrimack River in the background. Macintosh moved to Newburyport with his mother in 1833, some six years before Perkins took the earliest documented photographs in America on November 8, 1839. (Courtesy Brownie Macintosh.)

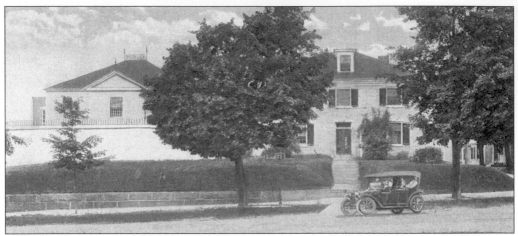

JAIL AND JAIL-KEEPER'S HOUSE, AUBURN STREET (C. 1910 POSTCARD PUBLISHED BY C.T. AMERICAN ART, CHICAGO, ILLINOIS). Situated at the northwesterly end of the Frog Pond, these impressive granite buildings were constructed in 1824–25. The cornerstone was laid by the Marquis de Lafayette on his second and final triumphal visit to America in 1824. "America's hero," Lafayette, may have met Philip Bagley, who was deputy sheriff of Newburyport for about 30 years, during the period of the Revolutionary War. (Courtesy Lunt Collection.)

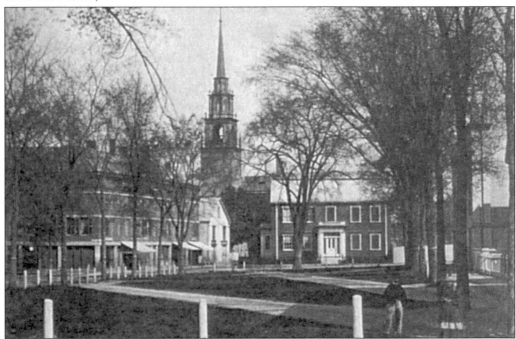

BROWN SQUARE LOOKING TOWARD THE INTERSECTION OF PLEASANT (LEFT) AND GREEN STREETS (C. 1885 STEREO VIEW BY SELWYN C. REED). Two churches are the only buildings to survive *in toto* from this period, and they are the Unitarian Church on the former street and the Baptist Church on the latter street. The large brick-and-granite commercial building at the left had its upper floors removed when it was remodeled. Harrison Gray Johnson, a Market Square lawyer, resided in the Greek Revival dwelling at the eastern head of Brown Square, where the post office is located. (Courtesy Nason Collection.)

BROWN SQUARE LOOKING TOWARD TITCOMB STREET (1905 POSTCARD PUBLISHED BY THE ROTOGRAPH COMPANY). A bronze statue of the internationally known antislavery reformer William Lloyd Garrison has a place of honor in the square laid out in 1801–02 through the munificence of rum trader Moses Brown. Newburyport sculptor David M. French modeled the statue, and it was presented to the city through the generosity of William H. Swasey on the Fourth of July in 1893. The Central Congregational Church is at the western end of Brown Square, and the First Baptist Church is at the left on Green Street.

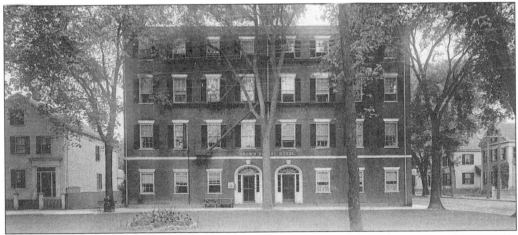

BROWN SQUARE HOTEL (1905 POSTCARD PUBLISHED BY THE ROTOGRAPH COMPANY). Wealthy merchant Moses Brown planned to build a row of houses on land he owned, beginning at Titcomb Street (right). He ended up building only the two sections of a brick row, with matching neoclassical doorways and keystone lintels. Later used as a boarding house, the structure was remodeled in 1884 by Elisha P. Pride and named for the square on which it was located. Several owners later it became known as the Garrison Inn to pay tribute to the man and his statue nearby.

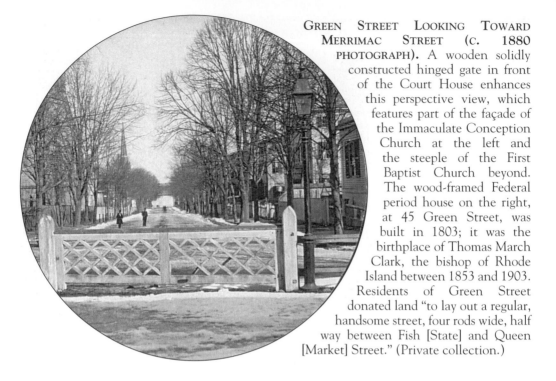

GREEN STREET LOOKING TOWARD MERRIMAC STREET (C. 1880 PHOTOGRAPH). A wooden solidly constructed hinged gate in front of the Court House enhances this perspective view, which features part of the façade of the Immaculate Conception Church at the left and the steeple of the First Baptist Church beyond. The wood-framed Federal period house on the right, at 45 Green Street, was built in 1803; it was the birthplace of Thomas March Clark, the bishop of Rhode Island between 1853 and 1903. Residents of Green Street donated land "to lay out a regular, handsome street, four rods wide, half way between Fish [State] and Queen [Market] Street." (Private collection.)

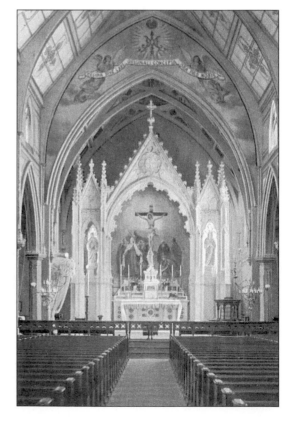

CHURCH OF THE IMMACULATE CONCEPTION INTERIOR, 34 GREEN STREET (C. 1909 POSTCARD PUBLISHED BY THE LEIGHTON COMPANY). The cornerstone of the Gothic-style church was laid in 1852, and the richly decorated interior features a painting of the crucifixion behind a white marble reredos. Painted above are two angels carrying a banner which bears the inscription *Regina Sine Labe Originali Concepta Ora Pro Nobis* ("Queen conceived without original sin, pray for us"). One of the early pastors of the church was Rev. A.J. Teeling, "a priest [who was] not only held in the highest respect by his parishioners, but by Newburyport's citizens in general of the era."

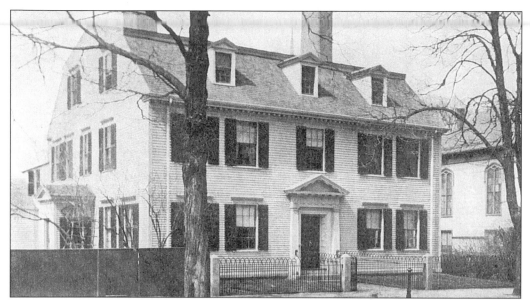

BRADBURY-SPALDING HOUSE, 28 GREEN STREET (C. 1910 PHOTOGRAPH). Involved in state and national politics during the 1790s, Theophilus Bradbury chose to have his home built on the most fashionable street in Newburyport, before High Street became the prestigious address. The imposing gambrel-roofed dwelling features a central entrance with an architecturally strong triangular pediment, which is repeated on the dormer windows. Next door is the First Baptist Church of Newburyport, constructed in 1848.

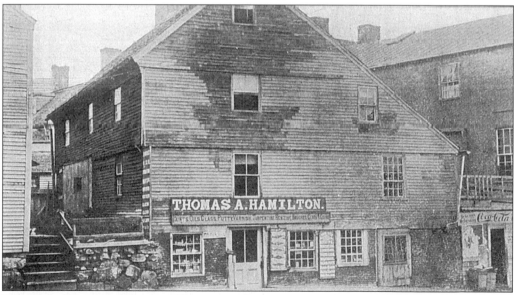

BENAIAH TITCOMB HOUSE, FORMERLY LOCATED AT 40 GREEN STREET (C. 1900 PHOTOGRAPH). The 19th-century trade sign of Thomas A. Hamilton, who lived in the house where he sold house painters' supplies, is in contrast to the script Coca-Cola sign above the door of the small addition. Benaiah Titcomb's lean-to dwelling with its double overhang was probably built after 1700 and moved some 200 years later to Essex, where it was restored. The main building of the police station was built to the left of the house in 1913, and the new addition on its site was constructed in 1998.

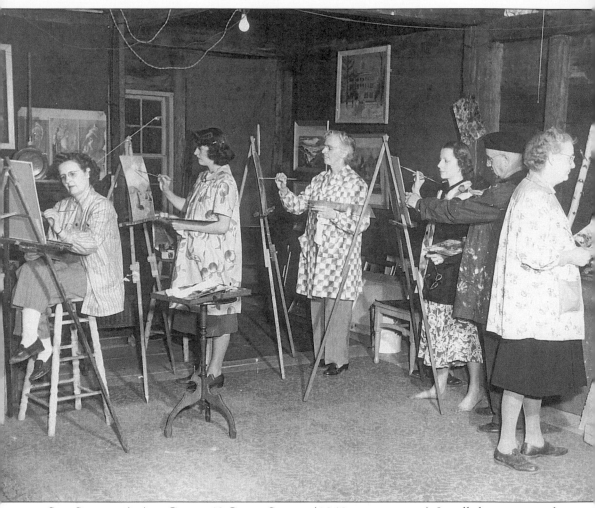

SAM SARGENT'S ART CLASS, 43 GREEN STREET (1948 PHOTOGRAPH). Locally born artist and teacher Sam Sargent (1889–1959) is now regarded as Newburyport's premier male artist of the 20th century. He founded the Sargent School of Painting in 1942 in the second-floor carriage house behind his residence, which was chartered by the Massachusetts Board of Education for almost 17 years. A well-respected landscape and seascape painter who "captured the accurate color and design of nature," Sargent founded the Newburyport Art Association, which is now located at 65 Water Street, in 1948. Aida Tedford (1910–1999), an accomplished still life and landscape painter, was Sargent's first pupil in 1942; they became close friends, painting and exhibiting together for decades until his death. (Courtesy Newburyport Art Association.)

HARRIS STREET MEETINGHOUSE, CORNER OF HARRIS AND PARK STREETS (C. 1889 PHOTOGRAPH BY OREN B. TASKER). Also known as the Second Presbyterian Church, the neoclassical-style building was destroyed by fire on August 7, 1983, while owned by the Annunciation Greek Orthodox Church. Deeply saddened by the loss of their adopted church, the Greek community banded together and built a contemporary church on the site in 1985. The Federal period house at the right was the home of Capt. William Nichols. It was constructed by merchant Leonard Smith at the time of his son's marriage during the first decade of the 19th century, and it was demolished in 1938. (Courtesy Laing Collection.)

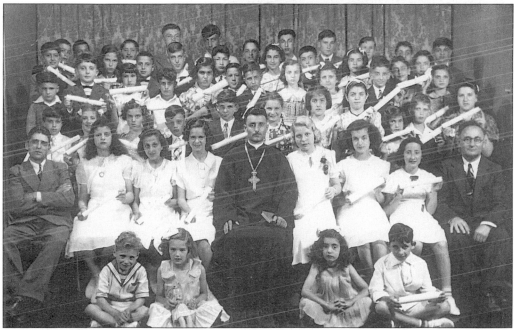

GRADUATION CLASS, GREEK SCHOOL, ANNUNCIATION GREEK ORTHODOX CHURCH, HARRIS STREET (1939 PHOTOGRAPH). Father Panagiotis (Peter) Frentzos is surrounded by students with their diplomas in the first six grades of the 1938–39 classes. John Lemnios, president of the church, is at the right, and John A. Matthews, the treasurer, is seated at the left; both gentlemen were founders and charter members of the church. (Courtesy Byron J. Matthews.)

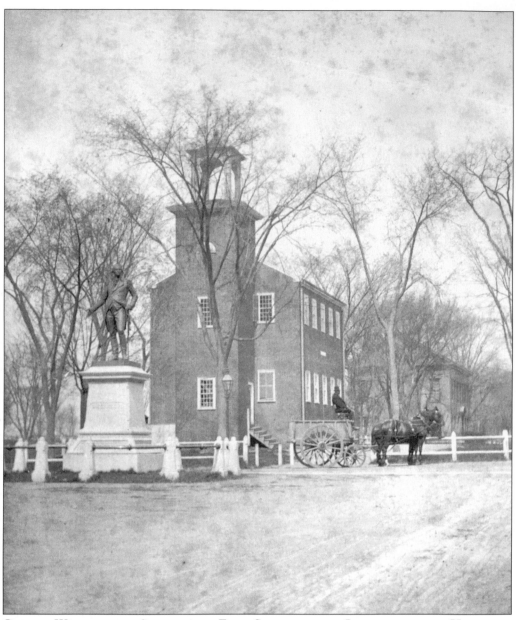

GEORGE WASHINGTON STATUE AND EAST SCHOOLHOUSE, INTERSECTION OF HIGH AND POND STREETS (C. 1880 STEREO VIEW BY HIRAM P. MACINTOSH). The East Schoolhouse was built in 1796 at the easterly end of Bartlett Mall; the second story, which was added to the brick schoolhouse in 1809, accommodated students from the Centre School. Early schools in Newburyport were often situated in peoples' homes, in the Court House, and in the vestry of the Federal Street Meetinghouse. Sculptor John Quincy Adams Ward (1830–1910) designed and modeled the heroic statue for Newburyport-born benefactor Daniel I. Tenney, a silversmith and jeweler in New York City, and it was cast in bronze there by George Fischer & Brother. "Picturesque and striking from all points of view," the statue was rededicated at the City Hall on February 23 (Washington's birthday), 1879, with appropriate exercises. (Courtesy William Varrell.)

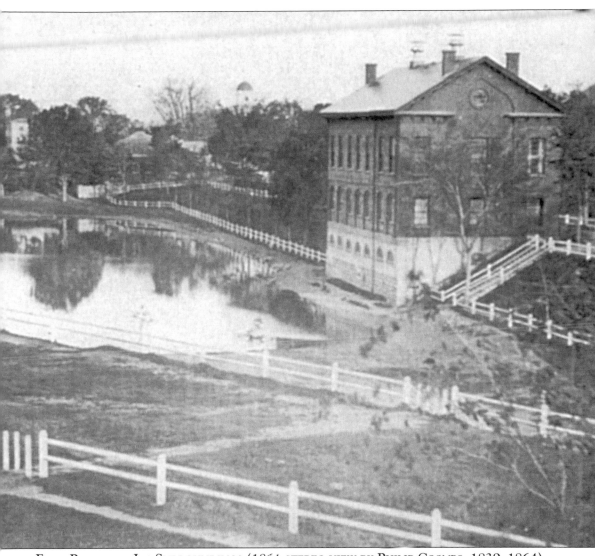

FROG POND AND ITS SURROUNDINGS (1861 STEREO VIEW BY PHILIP COOMBS, 1839–1864). Boston architect Charles Bulfinch's neoclassical-style Town and Court House of 1805, the High Street façade of which was remodeled in 1853 in the Italianate style, dominates the Frog Pond in this early image. Other partially visible structures include, from left to right: a Federal-period residence on Auburn Street; the West Male Grammar School at the end of Bartlet Mall; and the steeple of St. Paul's 1800 church, also on High Street. The Town owned the brick Court House for almost 30 years, then sold it in June of 1834 to the County of Essex. Located at the left front of the building is a cannonball attached to a granite post, along with a commemorative bronze plaque, which states: "Bombshell brought from the siege of Louisburg by Nathaniel Knapp Jr. 1759. Presented by his son Isaac Knapp as a memorial to his father and also to his brother Jacob Knapp who served at Bunker Hill and was a member of the crew of the privateer *Hero* of Newburyport. This ship sailed from Boston August 21, 1777, with a crew of 170 local men and was never heard from." The distinctive wooden fencing around the Frog Pond and Bartlet Mall was installed prior to 1801 to keep cattle out of the pond; it was popular with boys for vaulting and remained "in high style & good order" until the 1890s. (Courtesy Nason Collection.)

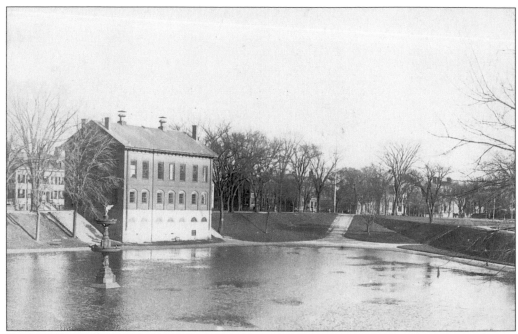

FROG POND AND BACK SIDE OF BARTLET MALL (C. 1900 PHOTO CARD; UNIDENTIFIED PUBLISHER). During the 1850s, it was calculated that the oyster-shaped body of water held 3.7 million gallons of water. Bartlet Mall was laid out in 1800 and was named to honor Capt. Edmund Bartlet, who donated $1,400 to beautify the area along the stretch of land in front of the Court House. A bronze plaque mounted on a boulder near the top of the stairs is inscribed with the history of the mall. The handsomely modeled cast-iron swan fountain, presented to the city in 1891 by Edward S. Moseley, Esq., has been maintained recently by the A.J. Corey family, as noted on a bronze plaque near the Pond Street side of this image.

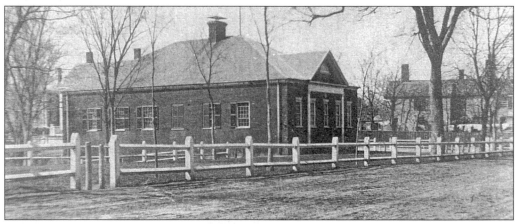

WEST MALE GRAMMAR SCHOOL, FORMERLY LOCATED ON BARTLET MALL NEAR AUBURN STREET (C. 1865 PHOTOGRAPH). A wooden schoolhouse was built on or near this site by the hay scales in 1790, and it was replaced by this brick, late-Federal–style structure in 1823. A conflagration in the early 1870s necessitated the removal of the charred remains. The Farnham House at the right was moved to lower State Street when the Kelley School was planned for that site. It boasted a fancy flower garden with one of the first surrounding brick walls in town. (Courtesy Laing Collection.)

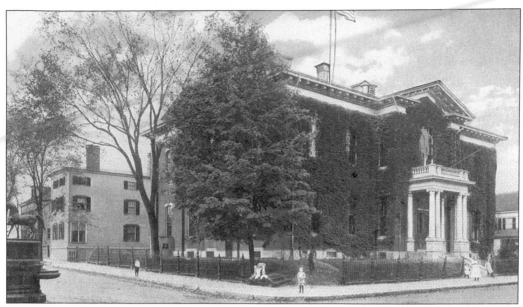

KELLEY GRAMMAR SCHOOL, 149 HIGH STREET (EARLY-20TH-CENTURY POSTCARD PUBLISHED BY C.T. AMERICAN ART, CHICAGO, ILL). Three of the school's pupils sit on a section of the Victorian cast-iron fence, which recently collapsed, at the corner of Auburn Street. The Italianate-style school was named to honor Dr. Elbridge G. Kelley, who served two terms in the 1870s as the city's chief executive; "1872 Kelley School" appears below the pediment for all to see. A prancing, cast-iron horse sculpture, known as the Taggard Fountain, once graced the tall watering trough nearby.

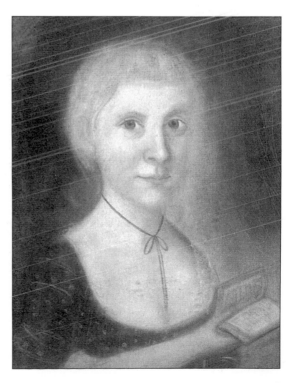

MOLLY HOYT (1773–1846, ATTRIBUTED TO BENJAMIN BLYTH, C. 1780). The Salem artist was in Newburyport when he limned this captivating pastel portrait of a well-dressed girl holding a special book. The daughter of Moses and Mary Stickney Hoyt, Molly probably attended a dame school "for young children . . . usually taught by middle-aged or elderly women, in cap and spectacles." Some of the women who taught the skills of embroidery and painting included Dame Moody and schoolmarms Emerson and Fowler.

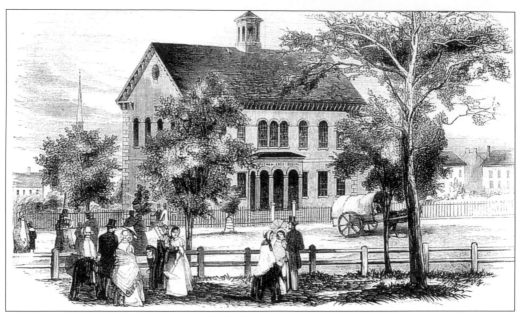

VIEW OF THE PUTNAM FREE SCHOOL, 144 HIGH STREET (1855 ENGRAVING IN GLEASON'S PICTORIAL DRAWING ROOM COMPANION). There was not a tuition charge for students who attended this school, thanks to the largesse of Oliver Putnam, Esq., a Newbury native. The two-story brick school in the Italianate style was dedicated on April 12, 1848, "for the establishment and support of a free English school in Newburyport." There were 80 students the first year, 40 of each sex, and while most were from local families, John E. Blunt hailed from Dalton, Georgia. William H. Wells was the first principal; Luther Dame was the teacher of mathematics and French; and Mary A. Shaw was the preceptress.

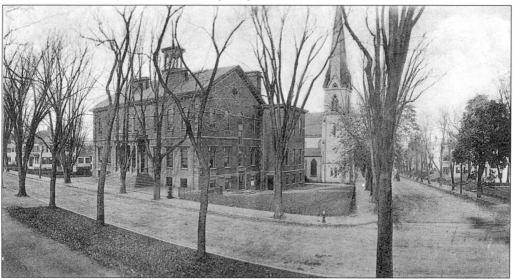

NEWBURYPORT HIGH SCHOOL, 144 HIGH STREET (C. 1900 POSTCARD PUBLISHED IN GERMANY FOR GEORGE H. PEARSON). The first high school in the city was established during the late 19th century in the former Putnam Free School at the corner of Green Street. The Church of the Immaculate Conception stands prominently at the right; although built in 1853, the steeple was not completed until 20 years later. (Courtesy Lunt Collection.)

48

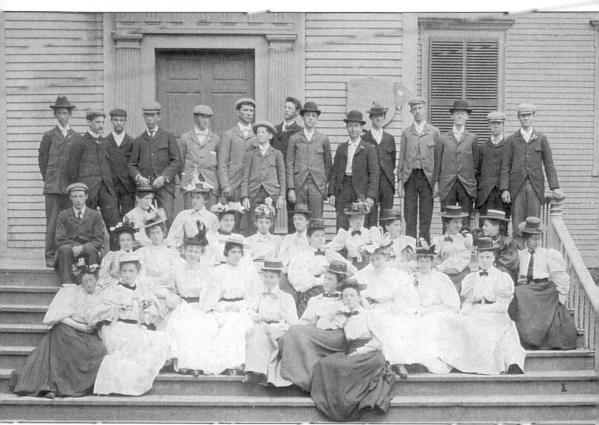

NEWBURYPORT HIGH SCHOOL CLASS OF 1896. Members of the graduating class pose on the front steps of the Harris Street Meetinghouse. The high school's class of 1894 held its graduation exercises at City Hall on June 26 at 2:30 p.m., with 25 students in attendance. The program opened with a piano duet by Carl Bohm, followed by a prayer and the singing by the school chorus of "Gloria" by Silcher. Ethel A. Brown's salutatory address was entitled "Progress," and Elizabeth M. Bartlett's essay "Cobwebs and Brooms" was combined with her valedictory address. Other musical interludes such as Gounod's "Vulcan's Song" and essays such as "The Supernatural in Shakespeare," by Clara M. Richardson, were offered before the awarding of prizes and the presentation of diplomas. Benjamin Woodbridge, a 17th-century young man from Newbury, was a member of the first graduating class at Harvard College. (Private collection.)

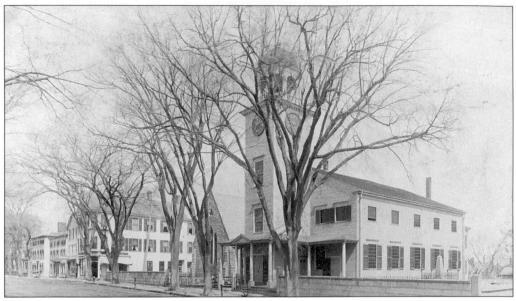

St. Paul's Episcopal Church, 166 High Street (c. 1908 photo card by an unidentified publisher). English-born merchant Joseph Atkins gave the land on the corner of High and Queen (now Market) Streets for the construction of St. Paul's Church. The first edifice of St. Paul's Church was built in 1739, and the second (shown above) was constructed in 1800. Most locals referred to the wood-framed edifice as "Bishop Bass's church," for the Right Reverend Bishop Edward Bass, the rector for over 50 years who was also the first bishop for the diocese of Massachusetts in the Protestant Episcopal Church. The gilded pine bishop's miter finial, attributed to woodcarver Joseph Wilson, adorned the steeple; and a cast bronze bell by Revere & Son of Boston, now on display in the entrance of the church, was placed in the belfry. (Courtesy Lunt Collection.)

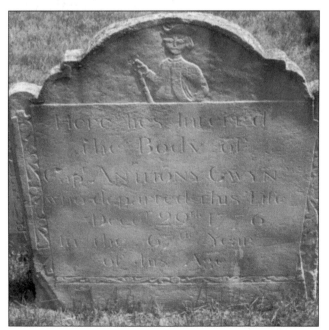

Gravestone of Capt. Anthony Gwyn, St. Paul's Episcopal Church Cemetery, 166 High Street (attributed to Henry Christian Geyer, 1777–78). The earliest surviving secular gravestone effigy in New England is that of British-born merchant Anthony Gwynn [*sic*], a founder, supporter, and vestryman of the church of England, who died on the last day of December in 1776. A cast reproduction replaces the original slate gravestone, which is on deposit at the Museum of Fine Arts, Boston. Prominent citizens were laid to rest alongside Mr. Gwynn; the first recorded burial was that of 17-month-old Elizabeth Davis in 1742.

ST. PAUL'S EPISCOPAL CHURCH, 166 HIGH STREET (C. 1940S POSTCARD PUBLISHED BY AMERICAN ART POST CARD COMPANY). The present church (1922–23) is the third edifice on the site, the 1800 building having burned in the fire of 1920. In the courtyard adjacent to Summer Street is the ivy-covered stone chapel, which was erected in 1862 by Rev. William Horton in memory of his daughter Anna M. Horton, who died in 1857. The home and pottery shop of Daniel Bayley was situated opposite St. Paul's Church and was where he and his three sons made and sold simple, utilitarian redware objects. The elder Bayley was also an organist and choir director at St. Paul's Church.

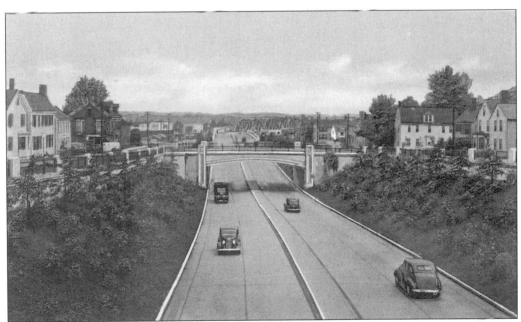

NEWBURYPORT TURNPIKE (C. 1940S POSTCARD PUBLISHED BY GENUINE CURTEICH, CHICAGO). When Route 1 bisected Newburyport in 1934, the "superhighway" plan brought about the demolition of many early houses in this area, looking north, between Winter Street on the left and Summer Street on the right. The former railroad bridge that traversed Low Street and was the direct route to the train station was referred to by some locals as "Guinea Bridge." In the 18th and 19th centuries, many descendants of black slaves and servants lived there in the field-like area called "the Outback."

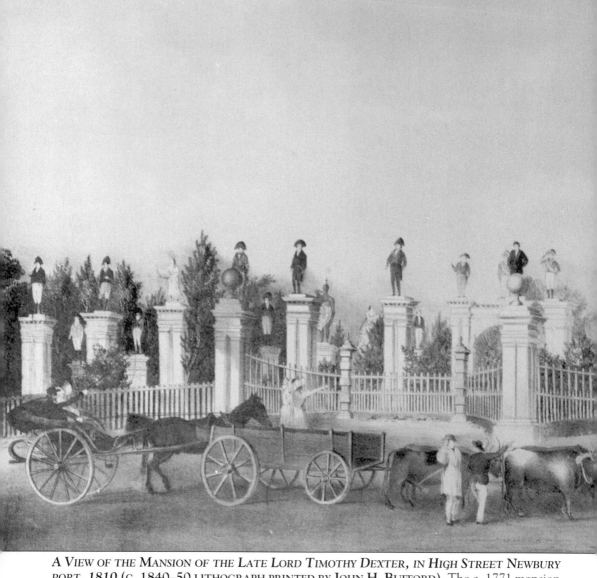

A VIEW OF THE MANSION OF THE LATE LORD TIMOTHY DEXTER, IN HIGH STREET NEWBURY PORT, 1810 (C. 1840–50 LITHOGRAPH PRINTED BY JOHN H. BUFFORD). The *c.* 1771 mansion at 201 High Street, which Timothy Dexter acquired in 1798 from initial owner and failed merchant Jonathan Jackson, took on a most curious aspect between 1799 and 1801. Townspeople and visitors were overwhelmed and amazed to watch as 45 larger-than-life-size, carved and painted figures (along with a lion and a lamb) were mounted on tall pedestals in front of the dwelling. Crafted by a ship figurehead carver named Joseph Wilson (1779–1857), who resided at 12 Strong Street, the sculptures of Dexter's most admired European and American historical figures remained *in situ* until many were sold at auction within a year of his death; others were toppled in the great gale of 1815; and the remainder were pulled down by the uncaring next owner of the property. The only remaining statue, thought to be of British statesman William Pitt, was acquired by Boston antiquarian James L. Little and in 1949, came into possession of the Smithsonian Institution in Washington, D.C. Restored a decade later,

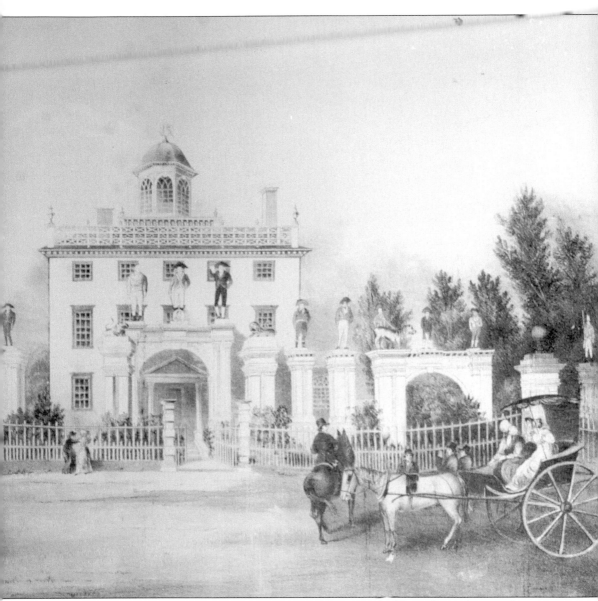

the imposing statue is now on deposit at the Historical Society of Old Newbury, along with two arms and a hand from another figure in the society's collection. While visiting friends in Newburyport, Salem minister and diarist Rev. Dr. Bentley noted on September 12, 1803, that "There is no horrid violation of proportion in the distinct objects but the vast columns, the gigantic figures, the extended arches, & absurd confusion of characters, tend to convince us of the abuse of riches. The vices of the man make us turn away with disgust. The temple of reason & the elegant coffin were shewn [sic] us [Dexter staged a mock funeral to see how his family and friends would react to his unexplained death], after the attendant had corrected a mistake from the absence of his recollection for a moment, in carrying to the necessary . . . which did not very much differ in its ornaments from the Temple. Dexter was within doors drunk having just suffered a heavy beating from his drunken son, urged on by a drunken daughter." The overly critical Rev. Dr. Bentley would not be surprised to learn that the subject of his tirade had beaten his "widow" when he saw that she had not expressed enough grief at his passing.

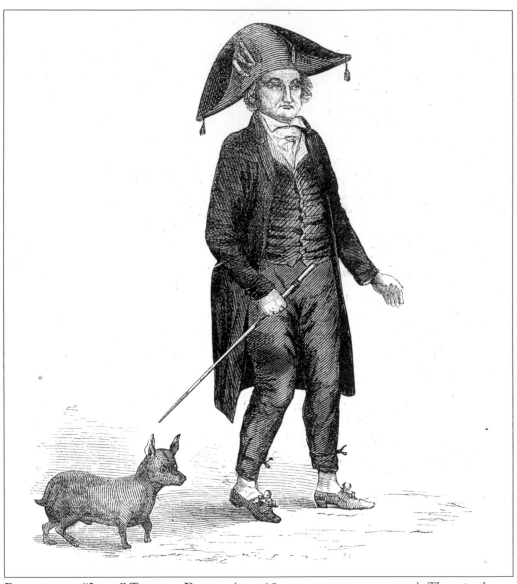

PORTRAIT OF "LORD" TIMOTHY DEXTER (MID-19TH-CENTURY ENGRAVING). The print James Akin produced of Dexter during his lifetime includes Dexter's hairless pet dog but not the doggerel in the upper left corner which states, "I am the first in the East, the first in the West, and the greatest Philosopher in the Western World. Affirmed by me, Timothy Dexter." His "poet laureate" Jonathan Plumer may have inspired Dexter to compose the self-aggrandizing verse. Known as an erratic entrepreneur and author during his lifetime, Dexter had his printer add almost a page of punctuation to the second edition of his 1802 pamphlet *Pickle for the Knowing Ones* so that his readers "may peper and salt it as they plese."

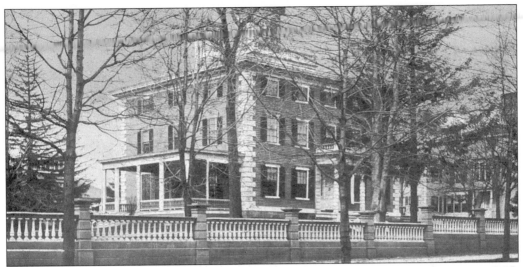

TINGLEY HOUSE, 201 HIGH STREET (EARLY-20TH-CENTURY POSTCARD PUBLISHED FOR S.H. KNOX & COMPANY). Madame Katherine Westcott Tingley purchased the Jackson-Dexter House in 1909. Leader of the Theosophy Society, Madame Tingley was a well-known eurythmic dancer, teacher, and practitioner. The Lowell-Tracy-Johnson House, next door at 203 High Street, was constructed c. 1774. Although close friends John Lowell and Jonathan Jackson vowed not to marry, each did and continued their camaraderie. Merchant John Tracy was the second owner, and in 1809 the house was acquired by patriot Eleazar Johnson, whose Newburyport Tea Party in Market Square in March of 1775 preceded by nine months the more famous destruction of tea in Boston Harbor.

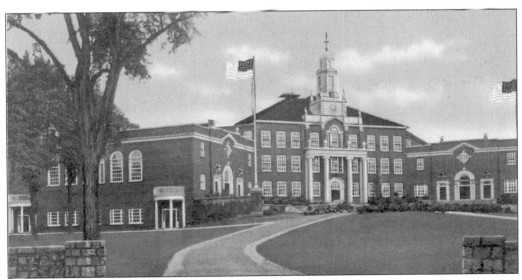

NEWBURYPORT HIGH SCHOOL, 241 HIGH STREET (C. 1940S POSTCARD PUBLISHED BY GENUINE CURTEICH). Built in the Georgian- or Colonial Revival–style in 1937, the building included the tower salvaged from the Victoria Mill on the corner of Water and Independent Streets; sunshine makes the gilded vessel weathervane sparkle. The stone walls of Joshua Hale's elegant estate, "Mount Rural," and its landscaped lawns were retained on the site.

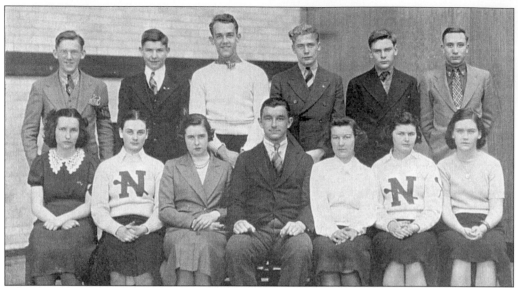

SCHOOL COUNCIL, NEWBURYPORT HIGH SCHOOL (1938 PHOTOGRAPH). The first full-year graduating class of the new high school had 194 members, under the aegis of Principal Joseph A. Ewart. Five class members who entered the service during World War II gave their lives for the sake of freedom. Classmates pictured are, from left to right: (seated) Anne Daley, Virginia Porter, Mary Dyer, Paul Roberts, Margaret Welch, Mary Lever, and Betty Murdy; (standing) Walter Morse, Thomas Foley, Clifford Marshall, John Holmes, Peter Lawton, and Roger Crockford. (Courtesy Lunt Collection.)

ENAITCHESS BOARD, NEWBURYPORT HIGH SCHOOL (1938 PHOTOGRAPH). Taking a break from their studies to put together a different class book, which featured a sailing vessel and the fascinating name Enaitchess (a phonetic rendition of "NHS") on the maroon, alligatored cover, are from left to right: (foreground) Angelo Sotiropoulos; (front row) Henry Walker, art editor; Annie Torosian; Margaret Burns; Alexander Maskiewicz, editor-in-chief; Virginia Hunter; and Carmella Garfi; (back row) John Boyjian; Walter Noyes; Paul Roberts; George Poulin; and Charles Witcomb, the business manager. (Courtesy Lunt Collection.)

GAYDEN WELLS MORRILL WITH "AUNT" CAROLINE, 209 HIGH STREET (C. 1894 PHOTOGRAPH). Caroline C. Cottrell came to Newburyport from Chattanooga, Tennessee, with the Morrill family to be Gayden's mammy. "Tair" was a person of such influence that Gayden once scrambled into her bed during a ferocious thunderstorm. She was so much a part of the family that when she died in 1918, she was buried in the Morrill family plot in Amesbury's Bartlett Cemetery. Often referred to as "persons of color" in early city directories, African Americans were part of the local landscape as early as the 18th century. Twenty blacks were born in Newbury prior to 1850—May was a "free molatta woman," and Pompey was the "servant boy" of Jonathan Harriman. (Courtesy Frank Forrest Morrill.)

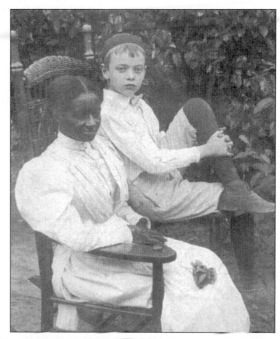

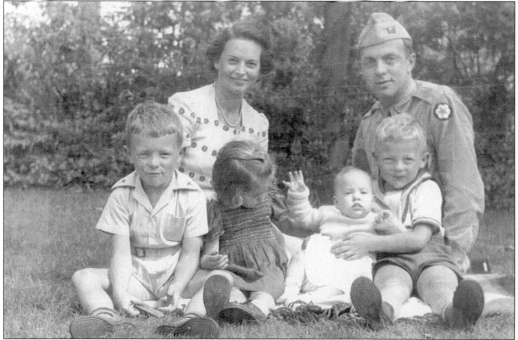

A BACKYARD SNAPSHOT, 209 HIGH STREET (C. 1944 PHOTOGRAPH). Capt. Frank Forrest Morrill, who was with ordnance in the U.S. Army during World War II, relaxes while on leave at the family home with his sister Margaret G. Wilkins and their respective children, from left to right: Gayden (Frank's oldest son), Margaret (named for her mother), baby Mary (Margaret's sister), and Robert (in front of his father). The children's grandfather, Gayden Wells Morrill, was Newburyport's "Depression period mayor"; he later told his son Frank that while in office, his best accomplishment was keeping the city out of bankruptcy. (Courtesy Morrill Collection.)

DANIEL PILLSBURY HOUSE, 267 HIGH STREET (1886 PHOTOGRAPH). A commemorative tablet on the end brick wall of the remodeled dwelling, which was partially destroyed by fire in 1889, states that "Pilsbery Place" was constructed in 1651. However, architectural investigation indicates the house dates from c. 1700. Another form of identification, a freestanding 1930 Massachusetts state marker, identifies the site with Edward Rawson, who was a secretary of the Bay Colony for 36 years and deputy to the General Court for 12 years during the 17th century. (Private collection.)

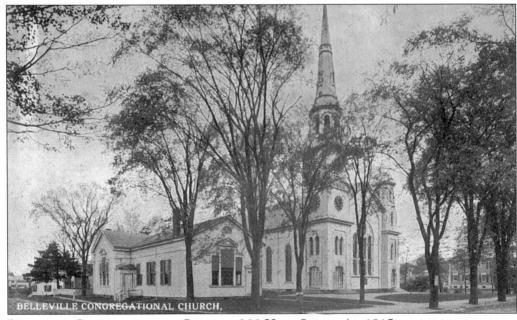

BELLEVILLE CONGREGATIONAL CHURCH.

BELLEVILLE CONGREGATIONAL CHURCH, 300 HIGH STREET (C. 1915 POSTCARD PUBLISHED FOR F.W. WOOLWORTH COMPANY). Located at the corner of Chapel Street, this "mighty fortress" has bold Italianate architectural features and towers of differing heights. Built in 1867 when the Reverend Daniel T. Fiske was pastor, the church was the third on the site, serving the prosperous shipbuilding families of Belleville. (Courtesy Lunt Collection.)

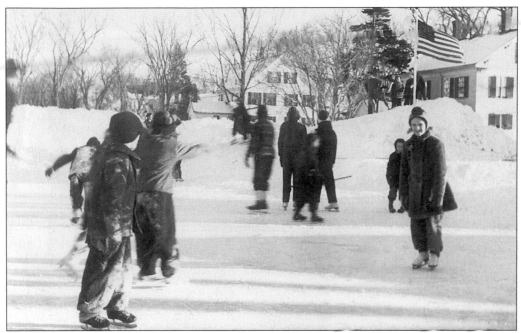

UPLAND SKATING RINK, CORNER OF HIGH STREET AND UPLAND ROAD (C. 1948 PHOTOGRAPH). Many Newburyport-area adults who grew up between 1942 and 1953 well remember the fun they shared on the pond that was flooded during the winter months behind the home of Mr. and Mrs. Raymond F. Blake. Over the years the flooded area grew in size until it encompassed an amazing 18,000 square feet and held as many as 200 skaters. Elizabeth Ronan pauses in the middle of a figure eight in front of an iced artificial hill, which was added for extra fun. (Courtesy Sally Blake Lavery.)

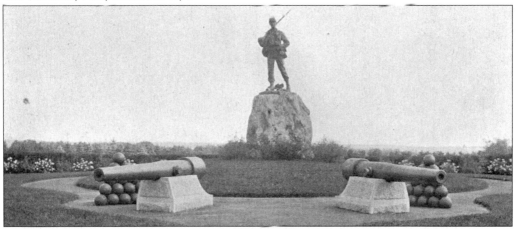

MONUMENT TO THE SOLDIERS AND SAILORS OF THE CIVIL WAR, ATKINSON COMMON, HIGH STREET (C. 1910 PHOTOGRAPH). The bronze sculpture of a Civil War soldier greets visitors to the landscaped grounds of Atkinson Common. Theo Alice (Ruggles) Kitson, wife of Boston sculptor Henry Hudson Kitson, modeled the youthful statue, which was unveiled on the Fourth of July in 1902. Other features of the park include the bronze Civil War memorial tablets in a U-shaped granite wall, a lily pond with an adjacent gazebo, a granite obelisk-shaped memorial dedicated in 1951 to the soldiers of all wars, and the stone observatory tower (closed for safety reasons).

VIEW FROM THE OBSERVATORY, ATKINSON COMMON, HIGH STREET AT THE THREE ROADS (C. 1910 PHOTOGRAPH). Located on High Street near Storey Avenue and Ferry Road, Atkinson Common was established on several acres of land by the 1867 will of Eunice Atkinson Currier. In 1894, the Belleville Improvement Society began "the work that has transformed the neglected field into a beautiful park, by grading the land, deepening the soil, laying out walls, and planting trees and shrubs." Other attractive parks in Newburyport include the Atwood Street Park on Atwood Street, Cashman Park between Boardman and Water Streets, Hale Park on Water Street, Joppa Park opposite Hale Park, Maudslay State Park on Ferry Road, Moseley Woods at the end of Merrimac Street, Waterfront Park and Promenade off Market Square, and Woodman Park off Crow Lane.

ANNA JAQUES HOSPITAL, 25 HIGHLAND AVENUE (EARLY-20TH-CENTURY POSTCARD PUBLISHED FOR F.W. WOOLWORTH COMPANY). Newbury resident Anna Jaques donated property on the corner of Broad and Monroe Streets for the city's first hospital. A later financial donation of $50,000 by William C. Todd, principal of the female high school, enabled the hospital's trustees to build a new facility on 10 acres of land on Highland Avenue, near the head of Arlington Street. The new hospital was completed and dedicated on June 28, 1904, a year following Todd's death. During the last decade of the 18th century, in 1793, an inoculating hospital for smallpox victims was established in the common pasture and a pesthouse was set up on Plum Island.

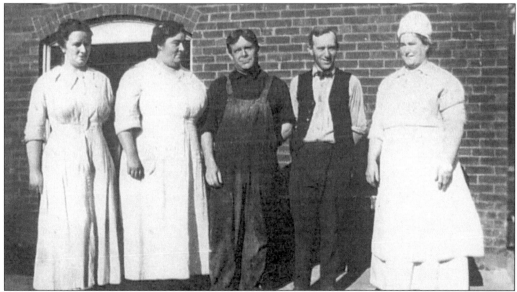

EMPLOYEES' BREAK, ANNA JAQUES HOSPITAL, 25 HIGHLAND AVENUE (1922 PHOTOGRAPH). Three women—a pair of laundry workers and the cook—flank another unidentified employee in overalls and John J. Hartnett, who was head of the maintenance department for over 43 years, as they enjoy one another's company briefly during a quiet time of the day. Hartnett was born in County Cork, Ireland, and immigrated to Newburyport c. 1895. The hospital maintained a vegetable and flower garden of about 3 to 4 acres and a root cellar, which Hartnett enjoyed working in as part of his duties. (Courtesy Raymond F. Hartnett.)

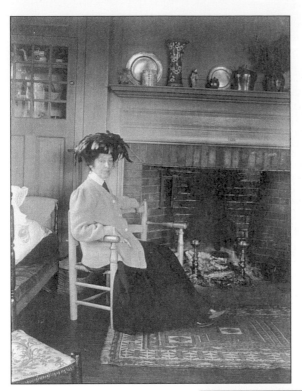

LAURA COOMBS HILLS AT HOME, 210 STOREY AVENUE (C. 1910 PHOTOGRAPH). The first lady of local artists strikes a relaxed pose in a painted carriage seat by the living room fireplace in the picturesque dwelling she had built in 1900, which was affectionately called "The Goldfish." Admired especially for her floral still life pastels, which she began exhibiting in the early 1920s, Hills delighted in designing valentines, Christmas cards, and posters for local charity events. A prolific self-taught miniature portraitist on ivory, Hills won medals for her "bright genius" between 1895 and 1916. (Courtesy Rick and Katherine Shelburne.)

LARKSPUR AND LILIES (C. 1930S PASTEL BY LAURA COOMBS HILLS, 1859–1952). Elected an associate member of the National Academy of Design in 1906, and a founding member of the Guild of Boston Artists in 1914, Laura Coombs Hills was honored by the Museum of Fine Arts, Boston, when it purchased her pastel *Larkspur, Peonies, and Canterbury Bells* in 1922; that popular picture was recently reproduced as a poster by the museum. *Larkspur and Lilies* exhibits a similar exuberant and crowded format, choice of colors, and deftness of touch. (Courtesy Lepore Fine Arts.)

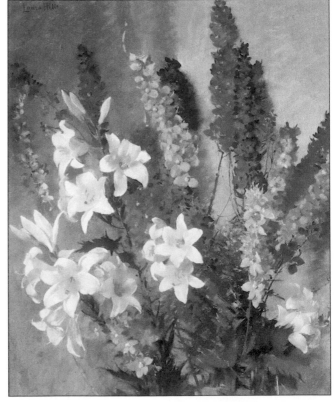

INN STREET LOOKING TOWARD MARKET SQUARE (C. 1880 PHOTOGRAPH BY OELWIN C. REED). Melting snow has revealed wagon wheel ruts in the dirt road of what was previously known as Mechanics' Row. The former ramshackle wooden buildings and the remaining brick structures housed various small businesses on the site that is now the Inn Street Mall, the first project completed in the urban renewal area in 1975 by the Newburyport Redevelopment Authority and the City of Newburyport. A citation for design excellence was presented to the redevelopment group by the Boston Society of Architects in 1984. (Private collection.)

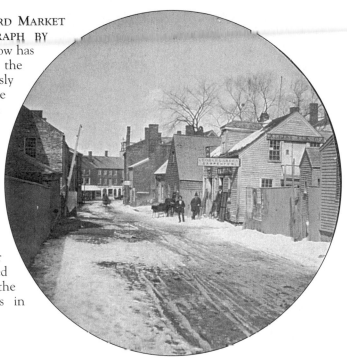

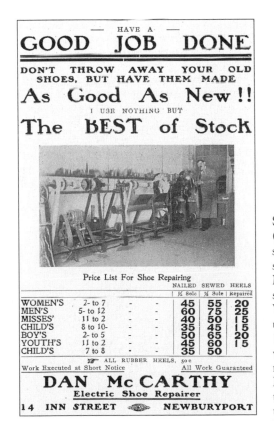

SHOE REPAIRER'S HANDBILL, 14 INN STREET (C. 1915). Daniel and Dennis McCarthy's shop was located near what is now the middle section of the brick row buildings on Inn Street Mall. Greek-born James Andriotakis had a shoe repairing shop at 15 State Street before World War II and then moved to Inn Street until he retired in the late 1960s. As early as 1807, the Newburyport Mechanic Association was formed for similar professions; the mechanics, along with members of the local Masonic lodges, benevolent associations, and tradesmen, enjoyed marching in parades during the early to mid-19th century.

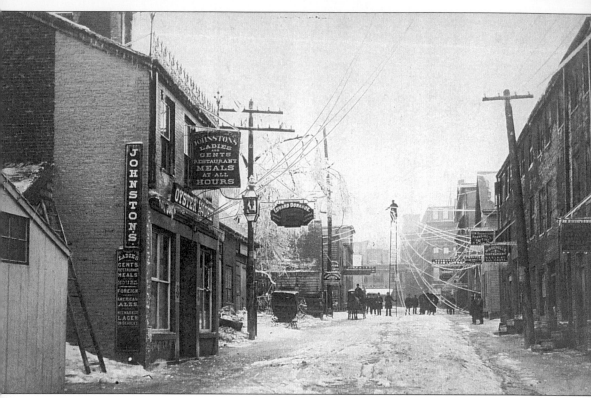

INN STREET LOOKING TOWARD PLEASANT STREET (LATE-19TH-CENTURY PHOTOGRAPH).
Icicle-covered trees and downed utility wires form interesting crystalline patterns along Inn Street after a winter storm. Oyster houses were popular restaurants in seaport cities, and they served the freshest bivalve mollusks only during months with an "r" in the name. Today, the Inn Street Mall is a trendy shopping spot and pedestrian way where families with young children enjoy the tot lot, and where locals and tourists relax on benches next to the splashing water of the contemporary stone fountain. (Private collection.)

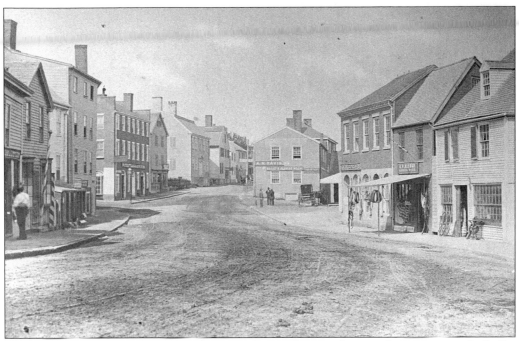

MERRIMAC STREET NEAR THE CORNER OF GREEN STREET (C. 1885 PHOTOGRAPH). Sadly, the only building still standing in this view is the three-story brick structure at the foot of Green Street, built *c.* 1829 for Moses Brown. Until quite recently it was "Newburyport's only downtown liquor store," known as "Canepa's." (Courtesy J. Richard Schneider.)

'WHAT'LL IT BE?' CANEPA'S, 43 MERRIMAC STREET (C. 1945 PHOTOGRAPH). Charlie "Johnnie" Canepa and his brothers John and Peter ran the business their father, Giovanni "John" Canepa, a native of Genoa, Italy, had established as a grocery store on the corner of Merrimac and Green Streets in the 1890s. Their liquor store, which featured "Real Beer," was opened after Prohibition ended. Charlie worked mainly in the retail store, while John was the wholesale fruit and produce man, and Peter made delicious ice cream until the late 1940s. (Courtesy Richard Canepa and Natalie C. Morris.)

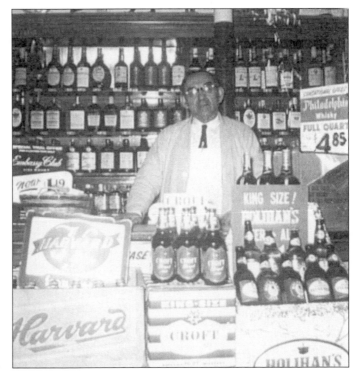

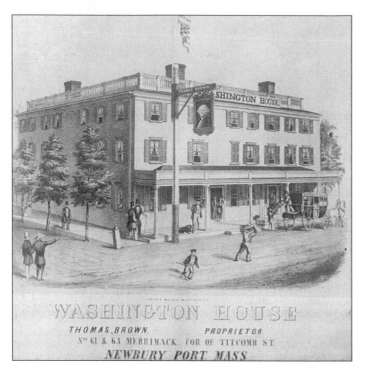

WASHINGTON HOUSE, 61 AND 63 MERRIMAC STREET (C. 1840S LITHOGRAPH). The Washington House was a busy establishment, located at the corner of Titcomb Street; the business name appeared on the stagecoach which transported guests to and from the hostelry. George Washington's portrait on both sides of the tall trade sign may have been painted over when J.P.L. Westcott assumed ownership of the renamed Ocean House. (Private collection.)

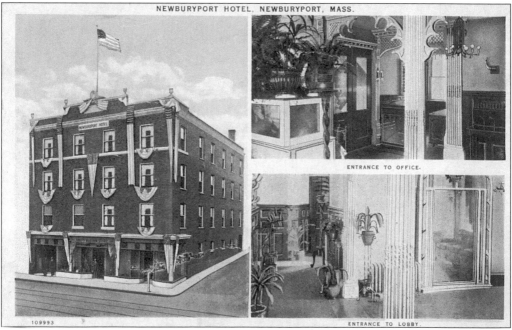

NEWBURYPORT HOTEL, CORNER OF MERRIMAC AND UNICORN STREETS (EARLY-20TH-CENTURY POSTCARD PUBLISHED BY CURT TEICH & COMPANY). Potted plants added a nice touch to the décor of this brick building, which advertised itself as being "A new, thoroughly lighted, up-to-date, fireproof hotel [with] rates moderately reasonable." The LaFontaine House on Middle Street boasted a "good billiard room" connected to the hotel. The names of the hotel's coproprietors were Noyes and Cheney.

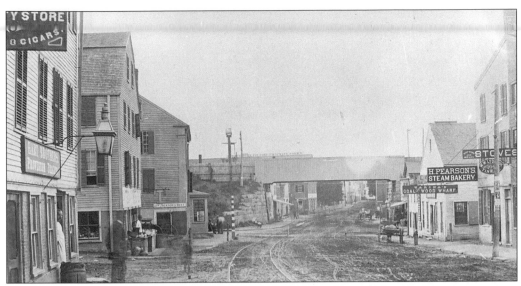

MERRIMAC STREET LOOKING TOWARD THE RAILROAD BRIDGE (C. 1880 PHOTOGRAPH BY SELWYN C. REED). Malt houses were in operation in town as early as the last decade of the 17th century; some were located at the foot of Ordway's Lane (now Market Street), and others were at the terminus of Chandler's Lane (now Federal Street). During the 18th century, distilleries were producing rum along the Merrimack River in the general area between Federal and Broad Streets. The last to close its doors, during Prohibition, was the distillery owned by Alexander and George J. Caldwell, located in the 1876 brick warehouse at 200 Merrimac Street on the wharf opposite the foot of Kent Street. (Courtesy Lunt Collection.)

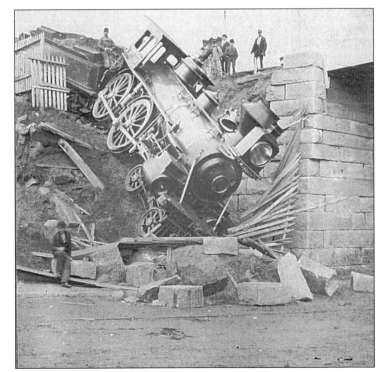

FRIGHTFUL RAILROAD ACCIDENT,' MERRIMAC STREET AT THE CORNER OF WINTER STREET (MAY 23, 1873 PHOTOGRAPH BY HIRAM P. MACINTOSH). One of the boys in the picture may have been the culprit who threw a switch sending the 440-type steam locomotive, no. 72 and some of its cars on a side track and thus off the embankment next to the granite bridge abutment. (Courtesy Nason Collection.)

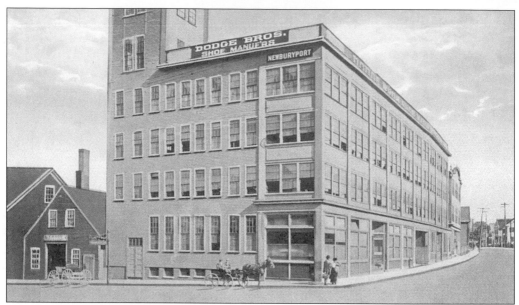

DODGE BROS., SHOE MANUFACTURERS. 112 MERRIMAC STREET (C. 1915 POSTCARD PUBLISHED BY C.T. AMERICAN ART, CHICAGO, ILLINOIS). This imposing four-story shoe manufacturing business was owned by Elisha Perkins Dodge, the most prominent shoe manufacturer in the city for more than 30 years. During the ominous year of the Great Depression (1929), Dodge was one of 18 local shoe manufacturers. The company specialized in women's turned shoes and had an average daily output of 500 pairs. Located opposite the foot of Summer Street, adjacent to the Newburyport and Salisbury Bridge, the factory was destroyed by a suspicious fire in 1934.

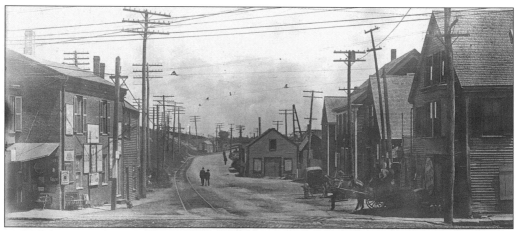

MERRIMAC STREET AT THE INTERSECTION OF THE NEWBURYPORT AND SALISBURY BRIDGE (EARLY-20TH-CENTURY PHOTOGRAPH). Tilting utility poles and crisscrossed wires add a staccato rhythm to this scene of gable-roofed structures, some proliferating with advertisements and varied notices. Not visible at the left was Pearson's Wharf, where H. Pearson's Steam Bakery was located. John Pearson Jr. was another wholesale baker there in the 1870s, specializing in "all kinds of Bread, including the celebrated Cream, Amber, Juvenile, Fruit, and Spice Biscuits." In 1911, the National Biscuit Company was listed as a tenant. (Courtesy Frank V. Kulik.)

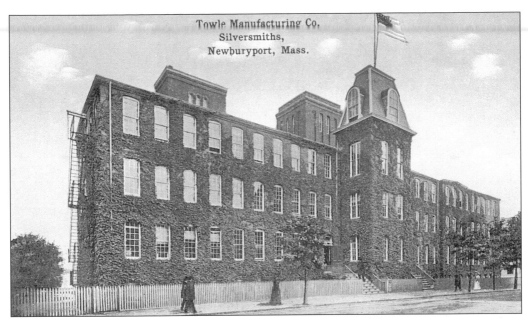

TOWLE MANUFACTURING COMPANY, 260 MERRIMAC STREET (C. 1910 POSTCARD BY AN UNIDENTIFIED PUBLISHER). Incorporated in 1880, the Towle Manufacturing Company in 1883 purchased the large brick factory erected in 1866 by the Merrimack Arms and Manufacturing Company at the foot of Broad Street. Anthony F. Towle and Edward B. Towle, father and son, were president and treasurer respectively. Many early- and mid-20th-century employees of the company referred to the busy factory as "the silver shop." The plant was closed in 1990, ending a long history of silver manufacturing in the city.

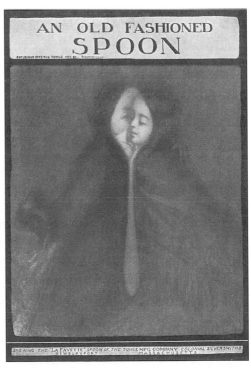

"AN OLD FASHIONED SPOON" (1909 POSTCARD PUBLISHED FOR THE TOWLE MANUFACTURING COMPANY). Four years after the "Lafayette" pattern was introduced in 1905, with a plain or an engraved handle, the Towle Manufacturing Company issued this charming postcard to attract young newlyweds. The Moulton name was associated with silversmithing in Newburyport for nearly 200 years, beginning with William II (1664–1732) and ending with Joseph IV (1814–1903). Young apprentices Anthony Towle and William Jones continued under the name of A.F. Towle and Son until 1882 when it was taken over by the Towle Manufacturing Company.

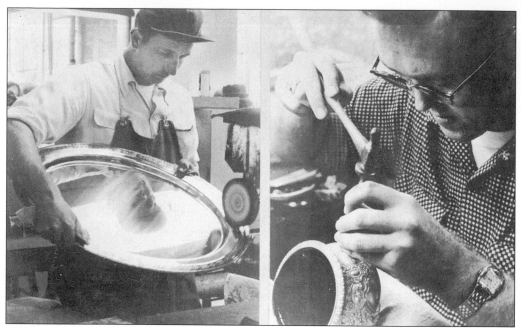

TOWLE SILVERSMITHS AT WORK (C. 1949 POSTCARD PUBLISHED BY DEXTER COLOR, NEW YORK). Photographed in the basement's drop room, the workman at the left burnishes a "King Richard" sterling silver tray, the largest piece of silver made at that time. Arthur Kellogg, a resident of Neptune Street in the South End, is chasing a sugar bowl in the same "King Richard" pattern, which was introduced in 1932. The job took Kellogg one week to complete. "Old Master" was one of the prolific firm's popular flatware patterns in the 1940s.

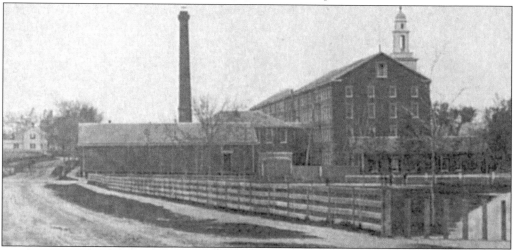

THE OCEAN MILLS COMPANY, BORDERED BY OCEAN, WARREN, MONROE, AND KENT STREETS (C. 1885 STEREO VIEW PUBLISHED BY WILLIAM C. THOMPSON). Encompassing a city block, the Ocean Steam Mills was incorporated in 1845, and the four-story brick factory was erected shortly thereafter. The factory was enlarged and changed hands a few times before it was purchased by Seth M. Milliken of New York, who renamed it Whitefield Mills. Cotton cloth continued to be manufactured there until 1889, when a state below the Mason-Dixon line beckoned with the proximity of a cotton-growing plantation and cheaper labor. (Courtesy Nason Collection.)

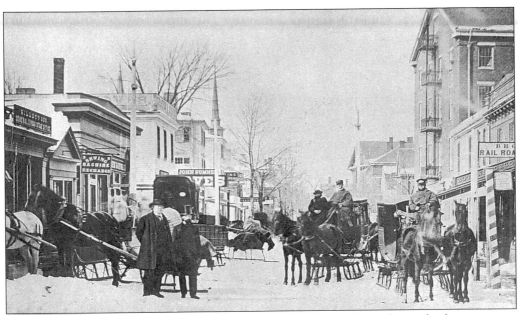

PLEASANT STREET WINTER SCENE (C. 1862 PHOTOGRAPH). Horse-drawn sleighs come to a halt on the busy street during the period of the Civil War. The young man holding the reigns in the middle vehicle was later known as the Honorable E.P. Shaw; the Reverend Daniel Pike, who was a pastor of the Middle Street Christian Church, stands at the far left. Some businesses located on Pleasant Street a decade later include T. O'Connell at number 9, a "dealer in hoopskirts, corsets, hosiery, gloves, buttons, braids, trimmings, and silk and velvet ribbons"; and Plummer and Newman at number 15, a dealer in "beef, poultry, mutton, pork, ham, vegetables, and fruit," as well as being an agent for the Great American Tea Company. (Private collection.)

PLEASANT STREET LOOKING TOWARD GREEN STREET (C. 1875 PHOTOGRAPH BY SELWYN C. REED). Prominent church spires which pierce heavenly Newburyport include, from left to right: the First Baptist Church on Green Street, the Central Congregational Church on Titcomb Street, and the Unitarian First Religious Society at 26 Pleasant Street. The large brick building at the right was built in 1837 as the Wessacumcon Steam Mills, and at one time it employed about 400 workers who manufactured brown and bleached sheetings and shirtings. (Private collection.)

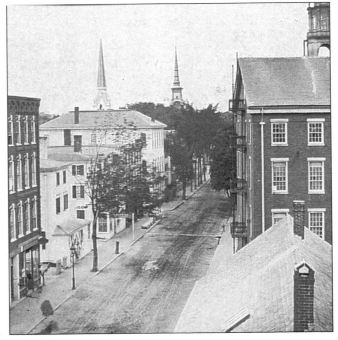

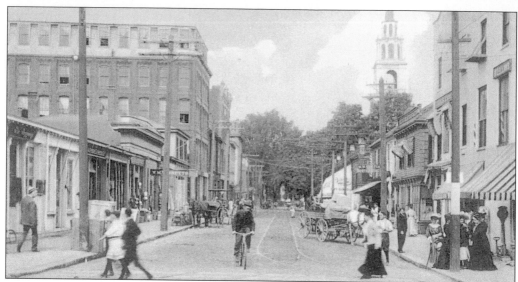

PLEASANT STREET (1905 POSTCARD PUBLISHED BY THE ROTOGRAPH COMPANY). Striped awnings, Edwardian ladies with flowery chapeaus, and a cobblestone street, along with the hustle and bustle of everyday life, imbue this scene with charm. The Bliss & Perry Company shoe factory at 21 Pleasant Street has on the façade a small keystone with the construction date of 1873. Of the three department chain stores located on this street, J.J. Newberry Company opened at the beginning of the Great Depression and outlasted its competitors S.S. Kresge Company and F.W. Woolworth Company, finally closing its doors *c.* 1973. Starting out in business on State Street, Benjamin Katz opened the Premier Market at 43 Pleasant Street in 1938, near the end of the country's financial doldrums.

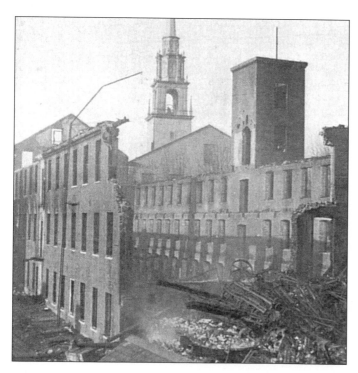

AFTERMATH OF THE BARTLET STEAM MILLS FIRE, 20 PLEASANT STREET (1881 STEREO VIEW BY SELWYN C. REED). The brick shell, stair tower, and a tangled mass of machinery and rubble from the former Wessacumcon Steam Mills frame the recognizable steeple of the Unitarian First Religious Society, fortunately spared in the blazing inferno. (Courtesy Nason Collection.)

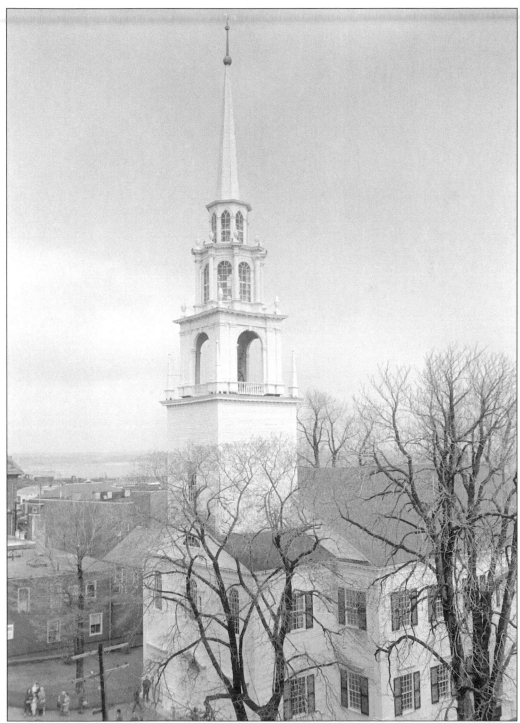

UNITARIAN FIRST RELIGIOUS SOCIETY, 26 PLEASANT STREET (1967 PHOTOGRAPH BY BILL LANE). A gilded weathercock perches proudly on the steeple of the 1801 Federal period church, thought to be designed by bridge engineer Timothy Palmer, and considered by all who see it to be the most outstanding ecclesiastical edifice of its period in America.

J.H. Bartlett Trade Card, 23 Pleasant Street (1879). A fashionably dressed lady sporting an ostrich-plumed hat and new shoes, follows her prancing pup on this bit of advertising for the shoe manufacturer Jacob Henry Bartlett. In 1854, Mrs. E. Vale Smith noted that by the second decade of the 19th century, many vessels from France "enabled our grandmothers to appear in costumes which would awaken the envy of many a modern belle."

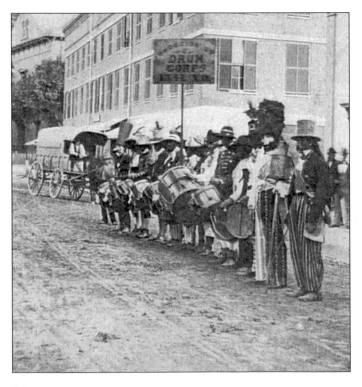

Excutionist [sic] Drum Corps on Pleasant Street (c. 1885 stereo view by Selwyn C. Reed). Members of the drum corps line up in front of the Young America Hook & Ladder Hose Company No. 1 (far right), which was located at that time in a wood-framed building at the corner of Unicorn Street. Miscellaneous headgear, colorful clothing, and black-face makeup gave the group a fascinating appearance. The driver of the ice wagon is craning his neck for a closer look in front of the mid-19th-century brick business block at the corner of Green Street. (Courtesy Nason Collection.)

POST OFFICE, 61 PLEASANT STREET (C. 1929 POSTCARD PUBLISHED BY GENUINE CURTEICH). Classical architectural details were incorporated in the brick government building at the corner of Green Street. In June 1891, the following personal advertisement appeared, of all places, in the *New York Sunday Herald*: "A pretty blue-eyed maiden, 24, worth $10,000, would consider matrimony." The ad was placed by "Pansy, box 356, Newburyport, Mass." Shortly thereafter, a follow-up appeared which stated that " 'Pansy,' the sweet man or girl who advertised with a view to matrimony, has a box full of letters in the post office; or did have this forenoon." 'Pansy' ought to have no difficulty in [making] a selection."

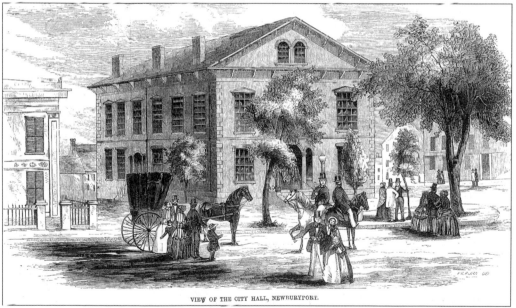

VIEW OF THE CITY HALL, NEWBURYPORT.

VIEW OF THE CITY HALL, NORTHWESTERLY CORNER OF PLEASANT AND GREEN STREETS AT BROWN SQUARE (1851 ENGRAVING IN *GLEASON'S PICTORIAL DRAWING ROOM COMPANION*). Small groups of citizens wear fashionable apparel in keeping with the 1851 construction date of the brick and brownstone Italianate municipal building. The city government was organized that year with historian and military leader Caleb Cushing serving as the first mayor. There were six wards established then, and a population check indicated that 12,866 people resided in the small city. Although remodeled, the earlier two-story building at the left retains many of the carved and applied wooden decorations of the Greek Revival style.

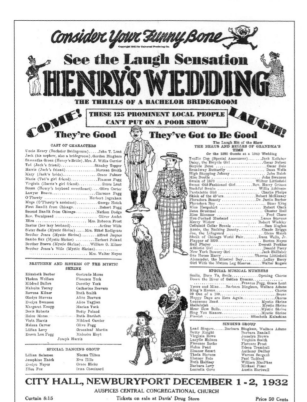

HENRY'S WEDDING BROADSIDE (1932). The surnames of many First Settlers' descendants, and those of more recently arrived settlers, appear in the cast of the comedy that was staged as an antidote during the early years of the Great Depression.

CITY HALL BARBER SHOP, 68 PLEASANT STREET (1917 PHOTOGRAPH). Proprietor Henry J. Chouinard (left) stands on the front step of the union barbershop which still bears his surname, near the City Hall. His friend Charles Antonopoulos, who ran a confectionery store near the corner of State Street, mimics the miniature cigar store Indian statue by the boxed cigar display. Of French Canadian descent, Chouinard came to Newburyport in 1910 from Livermore Falls, Maine, with his parents. Not being able to pursue his dream of becoming a lawyer, he nevertheless succeeded in business as a barber and then as a beautician until 1961, when he died at work. (Courtesy Robert Chouinard.)

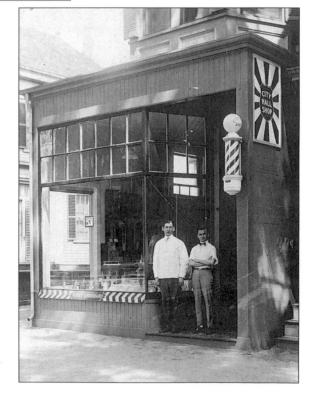

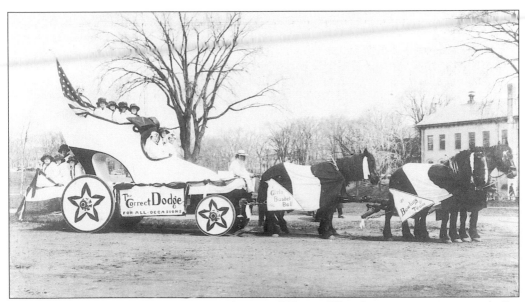

DODGE BROTHERS SHOE FLOAT, POND STREET (WORLD WAR I PERIOD PHOTOGRAPH). For this parade picture, employees of the Dodge Brothers factory on Merrimac Street perch in or behind the fashionable lady's shoe, along with two Red Cross volunteers. The quartet of horses, which have triangular banners to let the spectators know about the company's sports teams, also wear red, white, and blue to complement the float. (Courtesy McDonough Collection.)

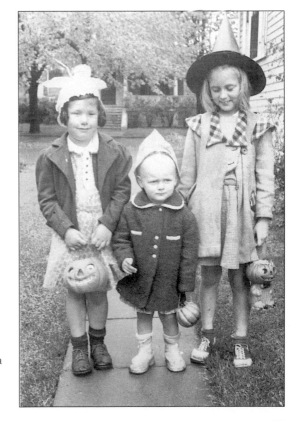

TRICK OR TREAT, PLUMMER AVENUE (C. 1941 PHOTOGRAPH). Kay Bauer took this snapshot of the Halloween trio waiting to fill their jack-o'-lanterns with childhood edibles. Sally Ann Blake (left), the daughter of Mr. and Mrs. Raymond F. Blake, and her friend Barbara Stone, seem to be having a better time than Barbara's sibling Ardith. (Courtesy Lavery Collection.)

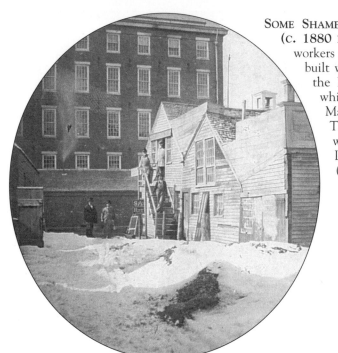

SOME SHAMBLES ON THREADNEEDLE ALLEY (C. 1880 PHOTOGRAPH). Businessmen and workers associated with this row of jerry-built wooden structures are dwarfed by the large brick Bartlet Steam Mills, which was destroyed by fire on March 18, 1881. The designation of Threadneedle Alley to this narrow walkway, which evidently has a London counterpart, is unclear. (Courtesy Nason Collection.)

TITCOMB STREET FROM MERRIMAC STREET (C. 1875 PHOTOGRAPH). A stagecoach makes its way down Titcomb Street with passengers from the Brown Square Hotel, visible behind it. The house in the background between the other two horse-drawn vehicles is on Washington Street. (Private collection.)

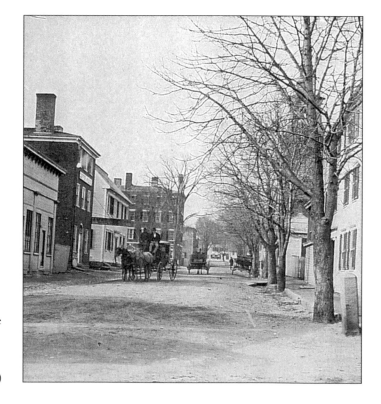

CIRCUS DAY, PROBABLY OFF STOREY AVENUE (1926 WATERCOLOR BY REYNOLDS BEAL, 1866–1951). Financially independent artist and yachtsman Reynolds Beal probably arrived in Newburyport under sail and hired a vehicle to take him to the "big top," which he painted with the colors and spontaneity of a child. Traveling circuses also set up at Cashman Park and on the Plum Island Turnpike. The premier circus to be held in Newburyport was actually an equestrian performance held in May 1811, the same month as the Great Fire. Toward the end of that century, in 1898, the circus parade that traveled down State Street had at least ten elephants and several camels in tow. (Courtesy McDougall Collection.)

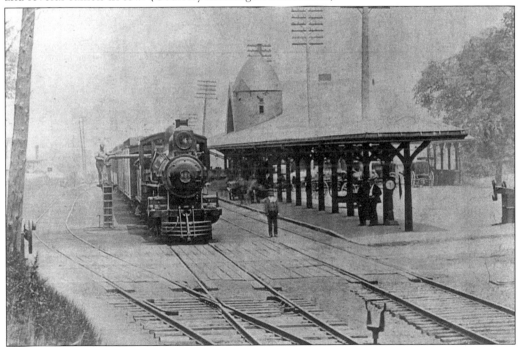

BOSTON AND MAINE RAILROAD STATION, WINTER STREET (C. 1895 PHOTOGRAPH). The Eastern Railroad Company and the Boston and Maine Railroad Company consolidated in 1884, a year or so after fire destroyed the wooden depot. A workman is filling the tender of steam locomotive no. 538 with water before the train leaves the c. 1892–93 Richardsonian-style depot and continues on its way to Boston. (Courtesy Walker Transportation Collection of the Beverly Historical Society & Museum.)

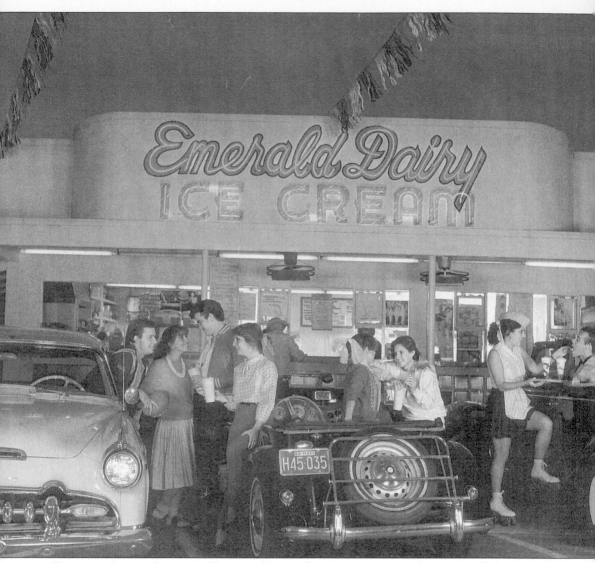

EMERALD DAIRY, ROUTE 1 TRAFFIC CIRCLE (1959 PHOTOGRAPH). Local well-dressed teens and well-maintained vintage cars were used in this evening photograph to advertise the delicious ice-cream cones, frappes, and sundaes on the menu at the well-known ice cream stand. Originally named Emerald Dairy by first owner Fred Kubic, it was renamed Haley's Ice Cream after it was purchased from his estate. (Courtesy Larissa Schumann.)

Four

DOWN-ALONG

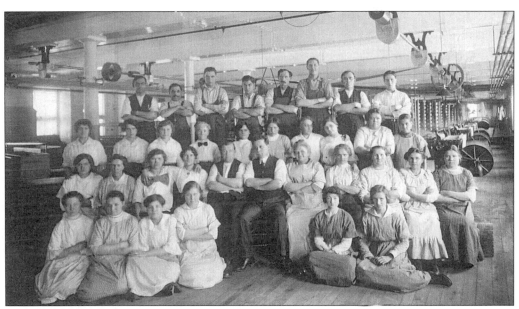

WARNER COTTON MILLS, 1 CHARLES STREET (C. 1915 PHOTOGRAPH). The surname of Charles T. James was given to the James Steam Mills, which was built in 1842 to manufacture cotton cloth. Two of the several Polish-born "spoolers" are Klementina "Mary" Kiman (first row, third from the left) and Adelia Burnos Awdey (third row, above her friend Mary). Statistical data in the 1963 book *Yankee City*—a pseudonym for Newburyport, and in which the names of streets and residents have been changed—relates to the ethnic backgrounds of immigrants who arrived in the city during the late 19th and early 20th centuries, where they chose to live, the occupations in which they were employed, and their upward or stationary mobility. According to the editors' population survey in 1933, the following ethnic groups arrived in Newburyport during these successive decades: Irish (1840–1850), French Canadians (1880–1890), Jews (1890–1900), Italians (1890–1900), Armenians (1900–1910), Greeks (1900–1910), Poles (1910–1920), and Russians (1910–1920). (Courtesy Helen Awdey Cole and Paul Jancewicz.)

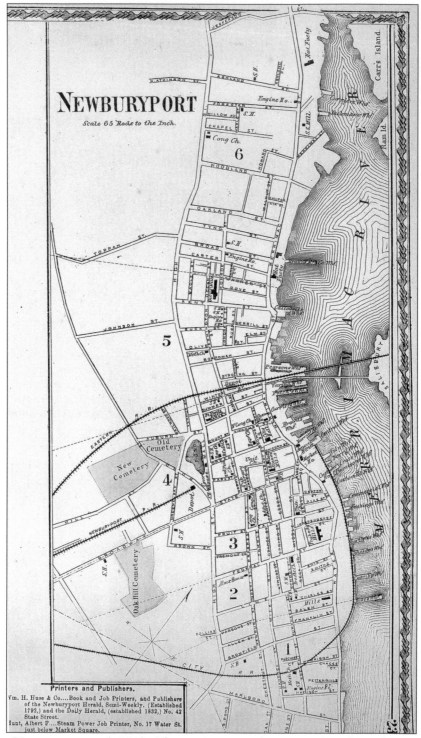

MAP OF NEWBURYPORT (1872). The city's six wards are numbered on this map, which includes the subscribers' business directory (partially shown).

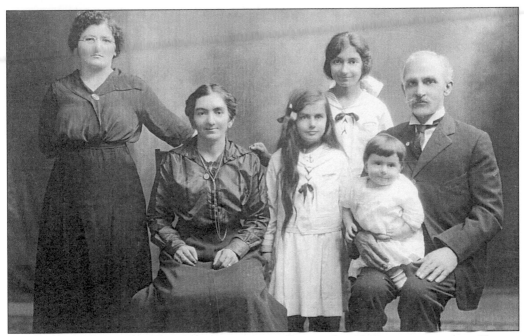

THE MINAS MAROOKIAN FAMILY, 10 BOARDMAN STREET (C. 1920 PHOTOGRAPH BY FRANK M. GOSS). Armenian natives Minas and Haiganoosh Marookian and their children Bernice, Gladys, and Arnold (seated on his father's lap) are joined by Mr. Marookian's cousin Justine Belinian (standing) for this family portrait. The forequarter of lamb Haiganoosh purchased on Friday for about 8 to 12¢ per pound at Harry and Oscar Kalashian's meat market at the foot of Titcomb Street was cooked on Saturday morning, along with the rest of the week's meals. (Courtesy Arnold M. Marookian.)

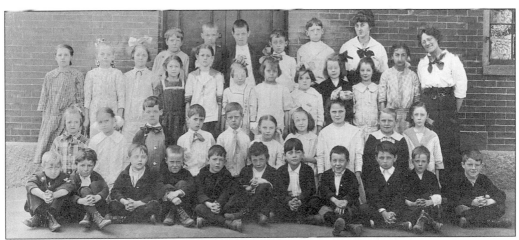

BROMFIELD STREET SCHOOL (C. 1915 PHOTOGRAPH BY ALBERT E. NYE). Thirty-seven students and two of their teachers, wearing middy blouses and black taffeta ties—popular women's apparel c. 1915 to 1925—pose by the front door of their school. Seated in the second row, far left, is Helen Atkinson, the daughter of Charles B. and Julia Lunt Atkinson, who for several decades was assistant curator at the Historical Society of Old Newbury along with her cousin, Wilhelmina V. Lunt, curator. (Courtesy Lunt Collection.)

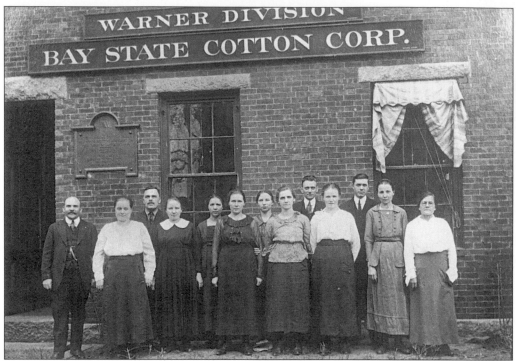

BAY STATE COTTON CORPORATION EMPLOYEES, CHARLES STREET (C. 1920 PHOTOGRAPH). The roster of employees at the textile mills in Newburyport during the late 19th and early 20th centuries reflected the growing number of Eastern European and French Canadian people being hired to keep the factories running smoothly. Standing beneath the bronze plaque of the office building that was formerly located behind the James Steam Mills is Barbara Taranda, while to her left and right are K. Korney and John Marciszka. Miss Nichipor, a sister or cousin of Mrs. Taranda, is second from the right. (Courtesy Michael Taranda.)

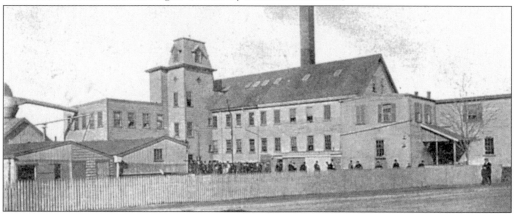

W.H. NOYES & BRO. COMB FACTORY, 28 CHESTNUT STREET (C. 1905 PHOTOGRAPH). Begun as a handicraft method of manufacture by Enoch Noyes in 1759, in the section of town later to be set apart as West Newbury, comb making became the first dominant industry in the development of the factory system in Newburyport. In 1871 the company was established in Newburyport and continued in operation for 50 years until destroyed by a fire. "Kinda Enochy" is an expression still used by West Newbury residents to describe someone who is a little strange but brilliant.

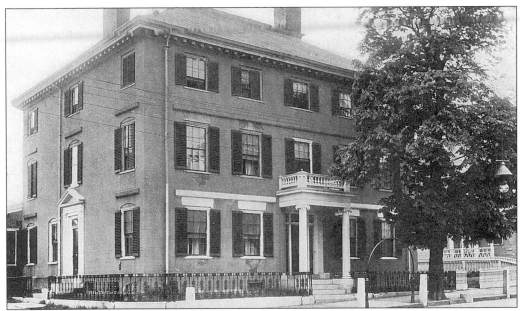

RESIDENCE OF WILLIAM BARTLETT, 17 FEDERAL STREET (LATE-19TH-CENTURY PHOTOGRAPH). The town's wealthiest merchant, William Bartlett had this four-square, brick Federal-period mansion built appropriately on Federal Street, c. 1798. The wide street was known initially as Chandler's Lane, then King Street; during or shortly after the Revolutionary War, it was renamed Federal Street. The epitaph on Bartlett's 1841 gravestone in Oak Hill Cemetery states that he was known for his "Firmness, Decision of Character and Habits of Thought and Action," and that he was known locally and in other countries "As a Distinguished Merchant and a Liberal Patron of Theological Learning."

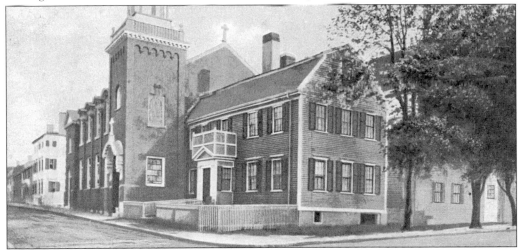

ST. LOUIS DEGONZAGUE FRENCH CATHOLIC CHURCH, 25 FEDERAL STREET (EARLY-20TH-CENTURY POSTCARD PUBLISHED BY THE LEIGHTON COMPANY). Located at the corner of Beck Street, this picturesque church bears the date 1904 on a cornerstone near the entrance. The former name of the ecclesiastical edifice paid homage to a boy saint of France, St. Aloysius. Fr. Raymond Plourde was instrumental in having the house in the foreground moved in the 1980s for a new entrance and in implementing the restoration of the 1890s organ enjoyed by past and present French Canadian members of the congregation.

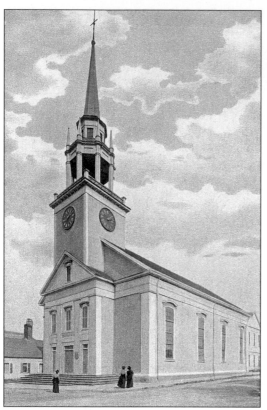

FIRST PRESBYTERIAN CHURCH, CORNER OF FEDERAL AND SCHOOL STREETS (C. 1910 POSTCARD BY THE LEIGHTON COMPANY). Built in 1756, and remodeled twice in 1829 and 1856, "Old South," which is now known as Old South United Presbyterian Church, was the bastion of earlier Newburyport families. When constructed, the church was the largest wood-framed meetinghouse in New England. Larger-than-life-size preachers dominated the pulpit for many years, including the Irish-born Rev. John Murray, referred to as "Damnation Murray" for the fiery sermons he proffered for 13 years, between 1780 and 1793. The imposing structure is familiarly known as the Whitefield church to honor the peripatetic preacher who was interred therein.

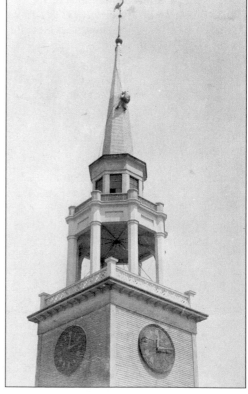

SPIRE OF THE "OLD SOUTH" CHURCH, CORNER OF FEDERAL AND SCHOOL STREETS (1907 PHOTO CARD BY AN UNIDENTIFIED PUBLISHER). The humorous inscription on the reverse states " 'Steeple Charlie' starting for the 'rooster.' He took it down & put it back *alone* by means of ropes and ladders, May-1907." Unidentified "Charlie" was the early-20th-century equivalent of today's "human flies." (Courtesy Nason Collection.)

WHITEFIELD MONUMENT IN THE OLD SOUTH CHURCH (1856 ENGRAVING IN GLEASON'S PICTORIAL DRAWING ROOM COMPANION). Prior to 1819, church attendees and visitors to the Whitefield Memorial in the fall and winter months felt as cold as the classical marble cenotaph since stoves were not in general use in Newburyport meetinghouses until then. Tin foot stoves, often with simple punched designs, and colorful woolen hand warmers provided some comfort during very long services. The last line of Whitefield's epitaph states: "He died of asthma, Septr. 30, 1770; suddenly exchanging his life of unparalleled labors, for his eternal rest."

THE REVEREND MR. GEORGE WHITEFIELD, A.M., (1769 MEZZOTINT PUBLISHED IN LONDON). Wheresoever the charismatic English-born evangelist George Whitefield (1714–1770) raised his hands in religious exultation and spoke in his clear resonant voice, people listened intently and usually donated money for an orphanage he had established near Savannah, Georgia. Whitefield, who crisscrossed the Atlantic Ocean frequently, preached in Newburyport several times. Following his last sermons in Maine and New Hampshire, he expired in the School Street home of his fellow minister Rev. Jonathan Parsons. (Courtesy Perry Hopf.)

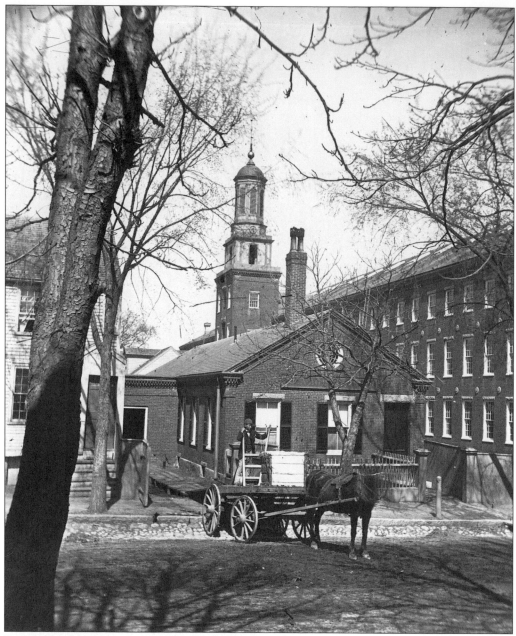

PEABODY MANUFACTURING COMPANY MILLS, FORMERLY LOCATED ON LOWER FEDERAL STREET (C. 1900 PHOTOGRAPH). The circular, or globe-shaped, window in the small counting room of the Peabody Manufacturing Company Mills was undoubtedly installed when the factory was owned by the Globe Steam Mills. It is still on its site at 12 Federal Street. However, the classical-style factory, which was built in 1846 to produce cotton cloth for the textile industry, was leveled in the past and is now on the site of The Tannery complex. (Courtesy Kulik Collection.)

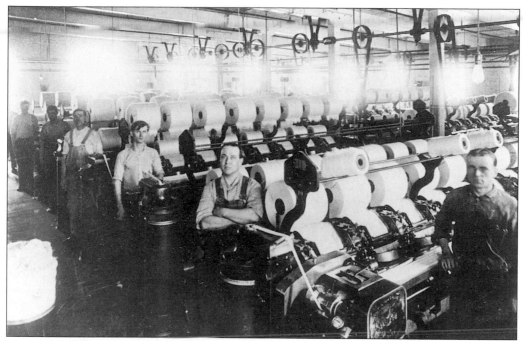

MALE MILL WORKERS' BREAK, FIRESTONE MILL, FEDERAL STREET (C. 1925 PHOTOGRAPH).
Known as the Firestone Mills during this period, the former Peabody Manufacturing Company Mills employed many newly arrived Polish immigrants, such as John Kulik, standing to the left of the man in the center of the picture. Each employee was responsible for the machinery and material rolling in his row. (Courtesy Kulik Collection.)

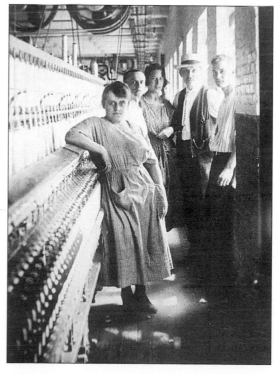

EMPLOYEES' BREAK, UNIDENTIFIED NEWBURYPORT COTTON MILL (C. 1920S PHOTOGRAPH). Many Eastern European and French Canadian men and women worked in the Yankee-owned textile and shoemaking factories off Water and Merrimac Streets during the late 19th and early 20th centuries. For economical reasons, and perhaps for homeland camaraderie, many first-generation couples often congregated near each other, often helping to bring up each others' children in the days before child care. (Courtesy Kulik Collection.)

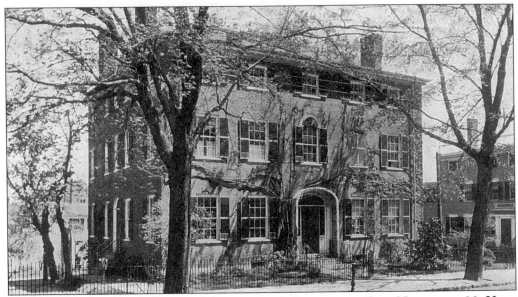

THE CALEB CUSHING HOUSE AND HISTORICAL SOCIETY OF OLD NEWBURY, 98 HIGH STREET (C. 1912 PHOTOGRAPH). The society's predecessor, the Historical and Antiquarian Society, was organized at the Lower Green on September 5, 1877, at which time some 2,000 enthusiastic history buffs were present. The second headquarters was in the Pettingill-Fowler House at 164 High Street. By 1955, the society acquired the former home of John Newmarch Cushing, whose son Caleb Cushing, Newburyport's most celebrated citizen, also lived there. The last family resident was Margaret W. Cushing, Caleb's niece, who resided in the dwelling for 100 years. Built in 1808, the Federal period mansion delights visitors with the treasures to be seen on a guided tour of 21 rooms and the Colonial Revival garden.

EAST PARLOR WITH PORTRAIT OF CALEB CUSHING (1800–1879). Flanked by neoclassical arches, the earliest known likeness of Caleb Cushing hangs in the formal room filled with family heirlooms and exotic oriental objects, located on the Fruit Street side of the historical society. Cushing was the author of the first local history, *The History and Present State of the Town of Newburyport* (1826), and was also the city's first mayor, elected in 1851. During the previous decade, he distinguished himself as the first U.S. ambassador to China (1842), and as brigadier general of the Cushing Guards, a militia group he organized to participate in the Mexican-American War in 1844. Formerly a good friend of President Franklin Pierce, Cushing later served as ambassador to Spain from 1874 to 1878.

WEST PARLOR WITH PORTRAIT OF MARGARET WOODBRIDGE CUSHING (1855–1955). Double end-wall arches, which highlight a mantelpiece and give depth to a room, were a popular architectural feature in Federal period Newburyport houses. Celebrated artist Cecelia Beaux (1855–1942) completed this oil portrait entitled *Miss Margaret* in 1917. A grande dame and keeper of the Cushing family flame, Margaret Woodbridge Cushing preserved her home by limiting the intrusion of many 20th-century innovations.

DINING ROOM WITH PORTRAIT OF JAMES AND WILLIAM HENRY PRINCE (1801 OIL PORTRAIT BY JOHN BREWSTER JR., 1766–1854). The most important painting in the Historical Society of Old Newbury is the large folk-art double portrait above the Victorian marble mantelpiece. This and the two accompanying portraits of other sons of James Prince were limned by the deaf-mute artist John Brewster Jr. while he resided temporarily in the family mansion on State Street. Brewster chronicled the daily lives of a wealthy family by showing some of their furniture, upholstery and window treatments, floor coverings, accessories, and fashionable apparel.

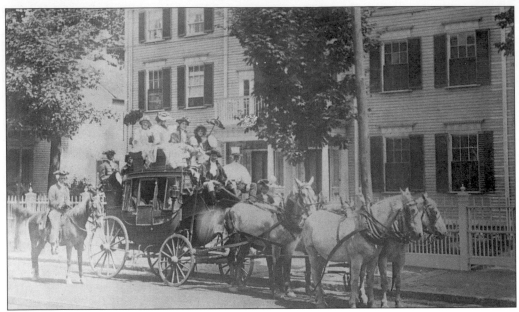

A COLONIAL COACH RIDE ON HIGH STREET (EARLY-20TH-CENTURY PHOTO CARD; PUBLISHER UNKNOWN). Architectural historian John Mead Howells has written that the Tenny-Noyes House at 102 and 104 High Street is "a perfect architectural expression of a double house." Built in 1807, the house was named for its owners Samuel Tenny and John M. Noyes. These names have been eclipsed by the ongoing legend that the dwelling's cellar has a tunnel that was used either by smugglers during the War of 1812 or as an underground railroad during the Civil War. The first scheduled stagecoach route between Newburyport and Boston was c. 1774; the people in this image are having a grand time "gadding about."

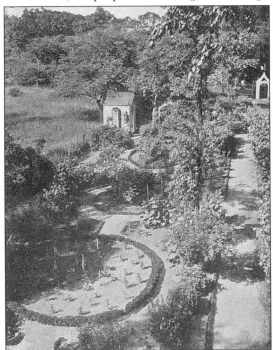

BOXWOOD GARDEN, JOSEPH AND WILLIAM MOULTON HOUSE, 89–91 HIGH STREET (C. 1912 PHOTOGRAPH). Federal period houses often featured gardens with a long axis or view. The formal garden behind the Moulton House, which was built in 1809, was laid out in 1840 by an English gardener named Clifford. The garden house with its closed roof (left), and the other fanciful similar structure with a trellis roof, were well documented by Works Progress Administration employees, who recorded the types of plantings used in and around the double-hourglass boxwood section of the garden.

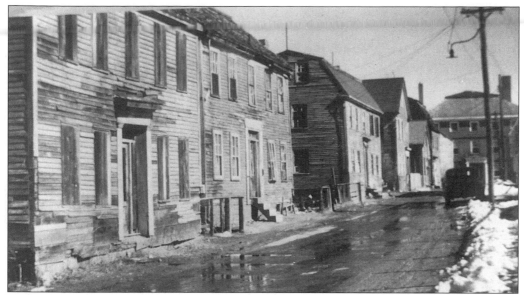

LIBERTY STREET LOOKING TOWARD FEDERAL STREET (EARLY-20TH-CENTURY PHOTOGRAPH). In the past throughout older cities and towns, most clapboarded houses—many of which were architecturally interesting, although not outstanding—were never repainted but were just left to "weather," often resulting in irreparable damage. These structures on Liberty Street met their ultimate fate when they were razed in the 1950s. Parking for The Tannery now occupies the site. (Courtesy Kulik Collection.)

TARANDA FAMILY WEDDING (1922 PHOTOGRAPH). Russian-born Timothy Taranda and his bride, the former Barbara Nichipor, both immigrated as teens to the United States, a few years apart. They were joined by family and friends in the celebration of their marriage at St. Nicholas Russian Orthodox Church in Salem. The Tarandas worked at the cotton mills in Newburyport and raised two children while they lived at 59 Liberty Street. (Courtesy Taranda Collection.)

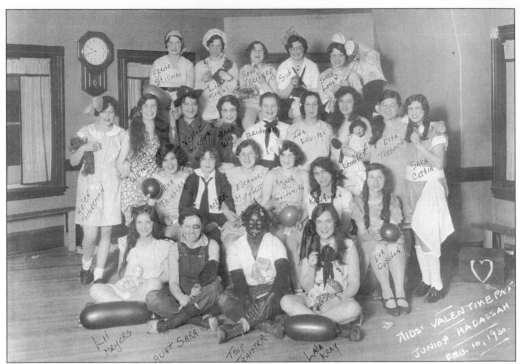

VALENTINE PARTY, LIBERTY STREET SYNAGOGUE (1930 PHOTOGRAPH). Many of the Junior Hadassah teenage girls in this review later became members of the synagogue's Sisterhood, which was formed locally in 1911. The present religious community was established in 1890 with the arrival of Jewish families during the late 19th century. Joshua B. Saklad was one of the first rabbis of Ahavas Achim Congregation, located on the corner of Washington and Olive Streets since 1934, when the building was purchased from the Upper Methodist Church. (Courtesy Bertha S. Woodman; Sadye E. Weiner Collection.)

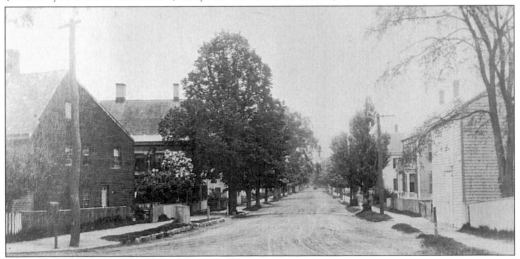

MARLBORO STREET LOOKING TOWARD WATER STREET (C. 1911 PHOTOGRAPH). Situated nearly opposite the Newbury-Newburyport town-city line, Marlboro Street was formerly known as Muzzey's Lane. It is the first Newburyport street that is perpendicular to High Street, and it is six blocks in distance to Water Street in the Joppa Flats area. (Courtesy Nason Collection.)

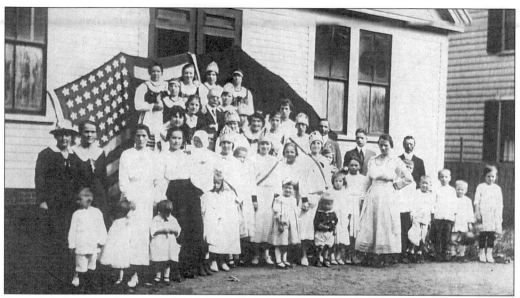

POLISH-AMERICAN CITIZENS CLUB, 3 SALEM STREET (C. 1923 PHOTOGRAPH). Glad to be living in America and proud of their homeland, these Polish American adults and children pose in front of their social club before a celebration. Organized on July 19, 1920, and located in the former Catholic school near the corner of Water Street, the club was especially lively on Sunday afternoons before television became popular. (Courtesy Cole Collection.)

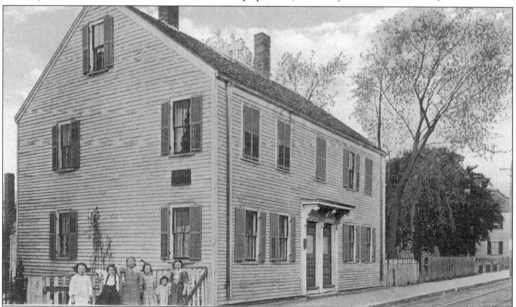

BIRTHPLACE OF WILLIAM LLOYD GARRISON, 3 AND 5 SCHOOL STREET (EARLY-20TH-CENTURY POSTCARD PUBLISHED BY C.T. AMERICAN ART, CHICAGO, ILLINOIS). A bronze memorial tablet to mark the 100th anniversary of the famous abolitionist's birth was unveiled by The City Improvement Society of Newburyport on December 10, 1905. Known nationally as an antislavery reformer for his publication and speeches, Garrison was incarcerated in jail for 49 days for publishing certain libelous remarks regarding the transportation of slaves in a local vessel owned by Francis Todd.

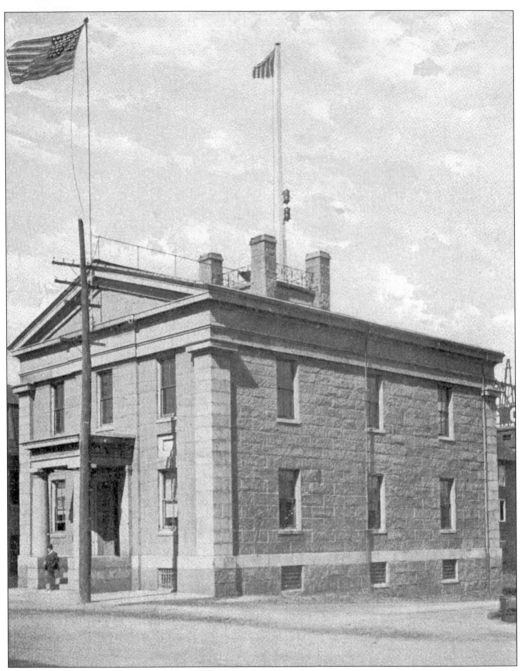

CUSTOM HOUSE, 25 WATER STREET (EARLY-20TH-CENTURY POSTCARD BY AN UNIDENTIFIED PUBLISHER). The most substantial building ever erected in Newburyport is the Custom House in the Market Square area. Built entirely of Rockport granite and brick, with the exception of the windows and their frames, the 1835 Greek Revival structure was designed by Robert Mills, who was the architect of the Washington Monument and federal buildings in the nation's capital. After serving as the federal Custom House for Newburyport between 1835 and 1911, the building and grounds were used as a scrap metal business until 1975 when it became the Custom House Maritime Museum.

Five

STATE STREET AND MARKET SQUARE

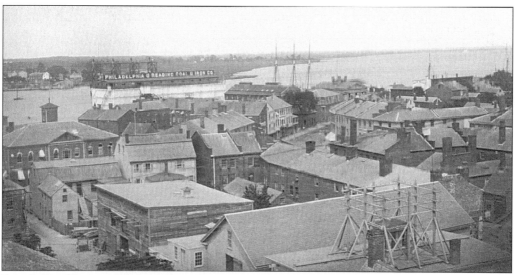

BIRD'S-EYE VIEW OF MARKET SQUARE AND THE MERRIMACK RIVER (C. 1880 PHOTOGRAPH).
The early-19th-century brick commercial structures erected in Market Square and some earlier
wood-framed residences are overshadowed by the large coal pocket built by the Philadelphia &
Reading Coal & Iron Company in 1876. Henry M. Cross, who was a wholesale and retail dealer
in coal, became an agent for the company after he disposed of wharf property he owned for the
construction of the coal-dispensing facility. A hundred years earlier, in 1772, the Town Way, or
Town Landing, was laid out from Market Square to the Merrimack River; it is still to the right
of the former Central Fire Station (previously the Market House), the brick building with the
hose-drying tower at the far left, and was known as the Middle Shipyard. Unicorn Street is at
the far left; part of it and the wood-framed structures in the foreground are now on the site of a
municipal parking lot. (Private collection).

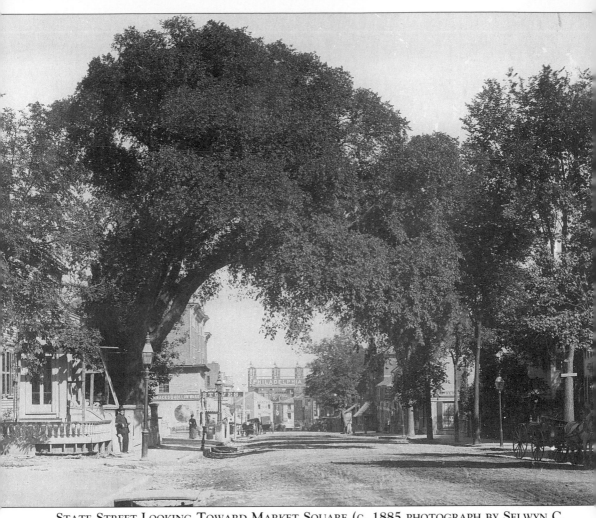

STATE STREET LOOKING TOWARD MARKET SQUARE (C. 1885 PHOTOGRAPH BY SELWYN C. REED). An immense, overarching elm tree frames brick and wooden structures along Newburyport's busy residential and commercial street two decades after the Civil War. The house at the far left with the curved balustrade-type fence was at the corner of Harris Street. Trade signs and posters proliferate on buildings on both sides of the dirt road. Philip H. Blumpey, a dealer in the "best family groceries," advertised "sperm, lard, solar and kerosene oil, [and] spermaceti candles" at his store on the corner of Temple Street, on the right, below the horse and wagon. The largest and most visible advertising sign is for the Philadelphia & Reading Coal & Iron Company, which was located along the waterfront. Situated in front of the large coal pocket is a brick Federal period building at 11 Market Square, the right half of which was painted white. Gas-illuminated street lanterns and arched footbridges over the gutters add further interest to this wonderful image. (Courtesy Morrill Collection.)

ANNIVERSARY PROCESSION HEADING DOWN STATE STREET (1885 STEREO VIEW BY SELWYN C. REED). On June 10, 1885, to celebrate the 250th anniversary of the founding of Newbury, several events were held to honor the First Settlers. Morning exercises with lectures and an evening promenade concert were held at the City Hall. During the afternoon two militia companies escorted a procession of dignitaries in carriages and public school children to a large tent on Bromfield Street, where dinner was served and more speeches were delivered. The inclusion of a large hand-painted banner, based on Gilbert Stuart's 1806 portrait of *George Washington at Dorchester Heights*, added an exciting and historic touch to the occasion. (Courtesy Nason Collection.)

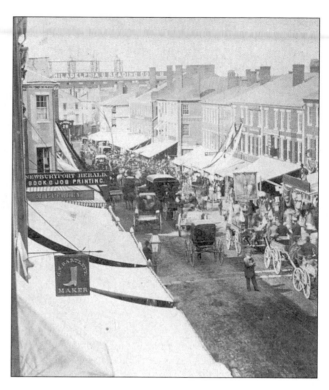

THE RECEPTION OF LIEUTENANT GREELY AT NEWBURYPORT (1884 ENGRAVING IN HARPER'S WEEKLY). An overwhelming public reception was accorded to native son Adolphus Washington Greely on August 14, 1884, for his command of the Lady Franklin Bay expedition to the North Pole. Greely and six of his starving companions were rescued by a government relief expedition. Beneath triumphal arches, the procession traveled down State Street and past Greely's home on High Street. Most impressive of all was the "arctic arch at night" on State Street, when fireworks illuminated the sky over the cloth-fabricated iceberg and carved albino polar bear.

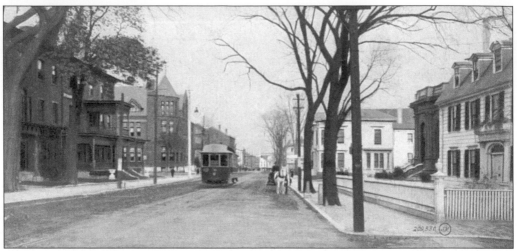

State Street Looking North (c. 1915 postcard published by the Valentine & Sons Publishing Co., New York and Boston). Known earlier as Greenleaf's Lane and then as Fish Street, State Street is graced by two distinctive structures at the right between Garden and Prospect Streets. Beyond the Dalton Club—built *c.* 1750 for Michael Dalton, and since 1897 a private club—and set back from the street, is the Italianate brownstone building that was opened in the spring of 1872 as the new location of the Institution for Savings in Newburyport. Twenty years later, electric car, or trolley, service was begun between Market Square and Salisbury Beach.

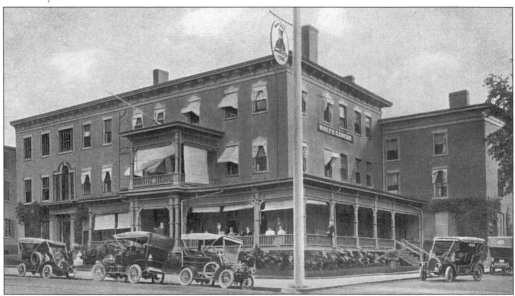

Wolfe Tavern, Formerly Located at 98 State Street (c. 1910 postcard published by the Leighton Company). Built in 1762, the original gambrel-roofed tavern was named to honor Gen. James Wolfe, the British general who was killed in 1759 at the Plains of Abraham in Quebec. The tavern changed hands, location, name, and architectural styles before it closed its doors for the last time in 1953 and was razed. The prominent oval trade sign with the portrait of General Wolfe was painted by Moses D. Cole after the 1811 fire, was repainted several times afterward, and was later donated to the Historical Society of Old Newbury. (Courtesy Lunt Collection.)

Y.M.C.A. Formerly Located at 76 State Street (c. 1900 postcard published for George H. Pearson). State Street has undergone noticeable change, as have practically all streets in America. Most recently, in 1987, a conflagration destroyed the brick-and-brownstone, Romanesque-style Y.M.C.A., which was "conveniently located, and exceedingly attractive from an architectural point of view." On January 1, 1892, invited guests enjoyed a grand reception and afternoon tea to celebrate the opening of the Corliss Memorial.

Newburyport Public Library, 94 State Street (late-19th-century photograph). The library located between Harris Street and Prince Place was originally built in 1771 as a residence for wealthy merchant Nathaniel Tracy. It had as its first distinguished overnight guest President George Washington, who visited Newburyport on October 30, 1789, while on a triumphal tour of New England. Washington's French compatriot during the Revolutionary War, the Marquis de Lafayette, also visited the mansion in 1824, when it was owned by merchant and collector of customs James Prince. The brick Georgian period mansion was purchased in 1864 and remodeled for use as a library. (Courtesy Newburyport Public Library.)

101

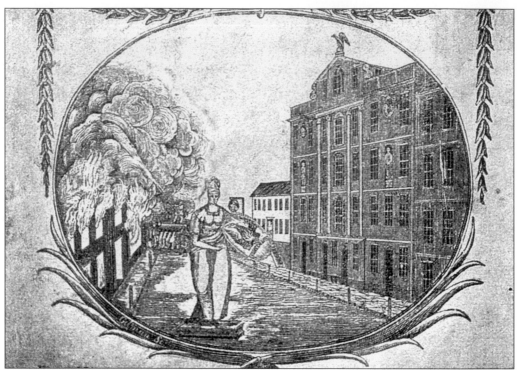

VIEW OF PHENIX [SIC] BUILDING, PREVIOUS TO THE GREAT FIRE. MAY 31, 1811 (CONTEMPORARY WOOD ENGRAVING). Holding an oval shield emblazoned with a phoenix, a classically garbed goddess stands in the middle of State Street, with the Wolfe Tavern in the background, while flames engulf the structure opposite the four-story neoclassical Phoenix Building. The tavern, the Phoenix, and many other buildings were destroyed in the 1811 conflagration. The fire began in the evening of the last day in May, spread across 16.5 acres in the center of town, and did an estimated $1 million worth of damage. It left 90 families homeless and hundreds of people out of work.

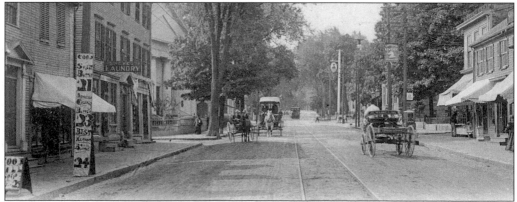

LOOKING UP STATE STREET (1905 POSTCARD PUBLISHED BY THE ROTOGRAPH COMPANY). Sing Kee operated a Chinese laundry on the corner of Temple Street opposite the former Whitefield Orthodox Congregational Church. The large columns and triangular pediment of the church, located at 81 State Street, are associated with the Greek Revival style. The driver of the wagon in the foreground may be planning to take a right onto Prince Place, where Greenough's livery trade sign with the horse's head is displayed on the utility pole.

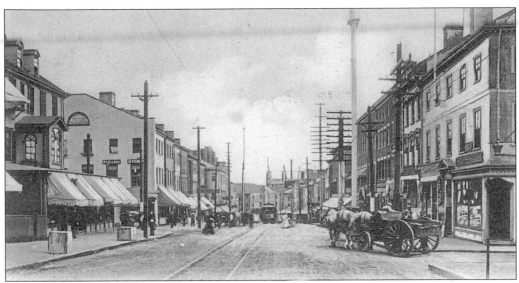

LOOKING DOWN STATE STREET (1905 POSTCARD PUBLISHED BY THE ROTOGRAPH COMPANY). On the corner of Pleasant Street (left), the row of eight brick Federal period structures with connecting fire walls met the law that was passed shortly after the 1811 fire to prohibit construction of wooden buildings exceeding 10 feet in height. Property owners realized that it was in their best interest to maximize space in what would again be the important retail area in the city. Dr. Micajah Sawyer's c. 1767 home (far left), was raised one story for commercial purposes during the late 19th century and then was razed c. 1925 for the same reason.

JAPANESE BAZAAR, 57 STATE STREET (C. 1870 PHOTOGRAPH). "Going to the Japanese Bazaar" proclaims the jaunty top-hatted silhouetted character on the sidewalk sign, directing passers-by to this unique shop on the corner of Charter Street, which was probably the earliest pet store in Newburyport. Three small American flags flutter in the breeze below the large store sign with pendant bird cages and a string of bells. Fans, shells, and other indistinguishable "foreign novelties" have caught the attention of the older, well-dressed gentleman. (Courtesy Nason Collection.)

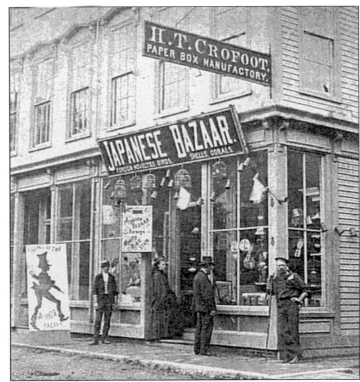

S.H. FOWLE, School Books and Stationery, Fruit and Confectionery,

15 STATE STREET, NEWBURYPORT-

S.H. FOWLE TRADE CARD, 15 STATE STREET (C. 1880S). Fowle's has been a well-patronized landmark on State Street for well over 100 years. The business's vintage 1930s neon sign survived the 1970s sign code regulations established by the Newburyport Redevelopment Authority. The *c.* 1939 soda fountain is a nostalgic feature, with its inlaid Dutch landscape of windmills and a goose girl. Always cool red-and-green marble covers the counter, and a similarly colored geometric marble design covers the floor. Unexpected curly maple veneer still adorns most of the interior. (Courtesy Ronald N. Tagney.)

A CUNNING CORDWAINER, WHITTIER GALLERY, 42 STATE STREET (C. 1897 PHOTOGRAPH BY WALTER R. FENLEY). The photographer and proprietor of the gallery printed this sepia-toned image of a youngster in a recently starched and ironed, wide cotton collar with matching sleeves and a small version of a shoemaker's apron repairing the sole of a man's brogan. LaRoy S. Currier, another photogenic Newburyport cobbler who wore a long white beard, made and repaired shoes in a "ten-footer" as a young man. (Courtesy Nason Collection.)

W.P. MARSH & COMPANY, 23 STATE STREET (C. 1895 ADVERTISING CARD). President William McKinley's wife, Ida, danced at the inaugural ball of 1897 in silk slippers that had Louis XV-style heels. The slippers were designed and made expressly for her by employees of the Newburyport Shoe Company, as ordered through a Canton, Ohio source. The company was located on Prince Place off State Street. (Courtesy Nason Collection.)

CHARLES C. STOCKMAN'S STORE, 10 STATE STREET (C. 1892 PHOTOGRAPH). Rocking chairs of wood and wicker, garden benches, and woven utilitarian baskets of various sizes were sold by Charles Currier Stockman and his sons George and Henry. Located between the second and third floors of the store at the left is a partially visible carved marble sign indicating that the building was the headquarters of the Marine Society. Founded on November 5, 1772, it was "the nucleus of a cabinet of curiosities," which by this time was fairly extensive and was called the Marine Society Museum. (Courtesy Laing Collection.)

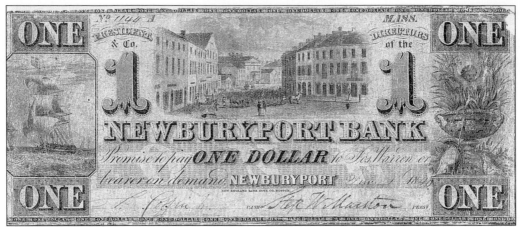

NEWBURYPORT BANK ONE-DOLLAR BILL (1840). The bank's importance to architectural historians is associated with this early engraved view of Market Square, depicting the recently constructed Custom House flanked by the North (left) and East Row brick commercial buildings. The bank was in existence from 1803 when it was founded to 1842 when its charter was repealed and canceled. (Courtesy Tagney Collection.)

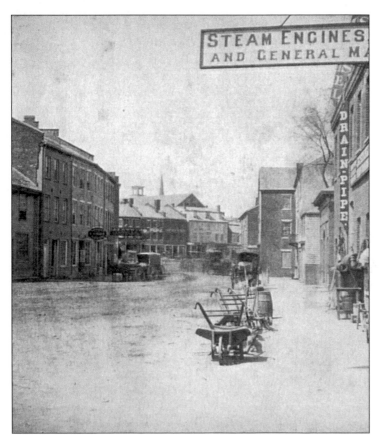

MARKET SQUARE FROM WATER STREET (C. 1880 PHOTOGRAPH). The drain pipe sign advertised the business of J.C. Stanley at 15 and 17 Water Street to be sellers of light and heavy hardware as well as "old metals and paper stock." Located behind the West Row in the center of the picture is the roofline of the Bartlet Mills, destroyed in the inferno of 1881. (Courtesy Schneider Collection.)

Market Square Looking Toward Liberty Street (c. 1870 stereo view by Hiram P. Macintosh). Flat trade signs with large letters advertise different businesses in the heart of the market area during a quiet time of the day. Isaac C. Clement offered West India goods and groceries in his store in the hip-roofed building in the North Row (left) where the black-and-white horses appear to be having a conversation. The Ocean Bank's office was on the first floor of the one-room-wide structure with the arched window flanking a similar entrance in the East Row. Tappan & Sons sold townspeople boots, shoes, and furniture in the variety store (to the right of the bank), and the large "Stoves" sign appears above John Chamberlain's name on the building at the corner of Liberty Street. Wood-burning cast-iron stoves with rococo scrolls and cabriole legs, or ones with neoclassical decoration and straight legs, were in vogue at this time before the advent of coal as a popular heating source. (Courtesy Nason Collection.)

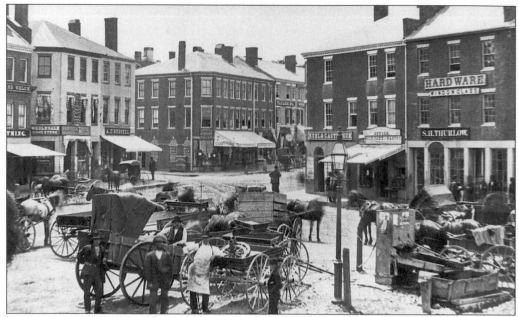

MARKET SQUARE LOOKING TOWARD MIDDLE (LEFT) AND STATE STREETS (1870 PHOTOGRAPH BY HIRAM P. MACINTOSH). Miscellaneous vendors congregate near the town pump in the area where the meetinghouse of the First Parish had been built in 1725. By 1850, 50 years after the church had been razed, merchants and shopkeepers in the square purchased a watering cart to keep down the dust from the horse-drawn commercial and pleasure vehicles; they were also concerned with beautification in a limited way. (Courtesy Lunt Collection.)

INFURIATED DESPONDENCY

INFURIATED DESPONDENCY (1805 ENGRAVING BY JAMES AKIN, 1773–1846). The heavy bell metal skillet that *American Coast Pilot* publisher Edmund March Blunt threw at engraver James Akin during a work dispute missed its mark. However, Akin got revenge for the broken window in his shop over the bookstore of Thomas & Whipple in Market Square. Blunt's engraved simian likeness was printed on the covers of Newburyport children's copybooks and on utilitarian vessels made in England, most infuriatingly on chamber pots. Although Blunt and his friends tried to purchase and destroy these Liverpool ware pieces, fortunately three survive to document this humorous local event.

108

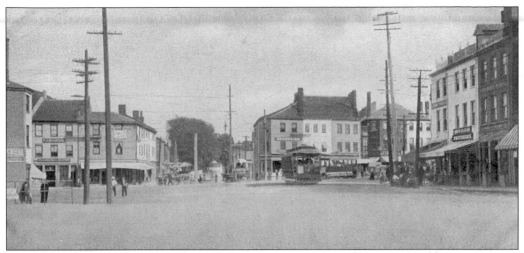

MARKET SQUARE AT THE INTERSECTION OF LIBERTY AND STATE STREETS (C. 1910 POSTCARD PUBLISHED BY THE METROPOLITAN NEWS COMPANY, BOSTON). Trolley cars converged in Market Square during the late 19th and early 20th centuries, this one turning in front of the South Row (erected in 1821), with the West Row at the right. In the past, many businesses, such as Pearl S. Bradford plumbing and heating, located in the East Row, opened at 7 a.m., giving customers ample time to shop.

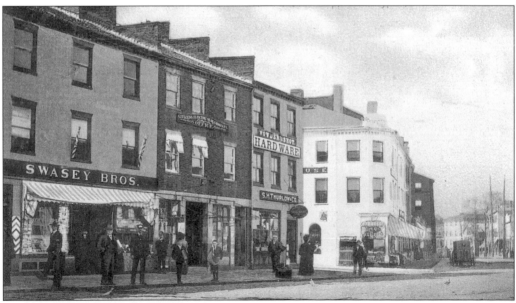

MARKET SQUARE AT THE INTERSECTION OF INN STREET (C. 1910 POSTCARD PUBLISHED BY THE ROBBINS BROS. COMPANY). Many artisans had shops or lived in the State Street area before and after the Great Fire of 1811. David Wood, the most prolific clock maker of the Federal period, had a shop in Market Square; Barnard Cermenati, a looking glass manufacturer, had his shop at 10 State Street during the first decade of the 19th century; and Nathaniel and Thomas Foster ran a watchmaking, jewelry, and silversmith shop on State Street from the 1820s to c. 1840.

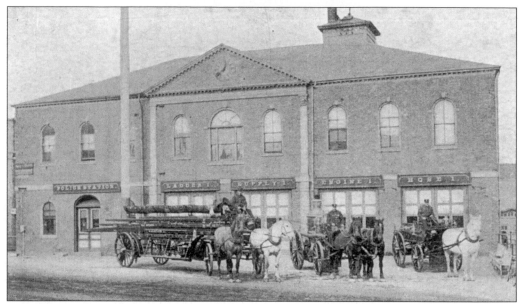

CENTRAL FIRE STATION, MARKET SQUARE (C. 1890S POSTCARD PUBLISHED BY EDWARD W. EATON). One of the first people to be associated with Market Square was an ambiguous character identified by a standing sign to the left of the former brick Market House, which pertains to the pre-1635 site known as Watts' Cellar. Before the Market House was constructed in 1823, butchers' stalls, or shambles, were located in the immediate area. The Central Fire Station was headquartered in the building from the 1860s to 1979. Remodeled in 1884 after the removal of the market stalls, the entire building was devoted to the fire and police departments. Remodeled again in 1988, after a period of long neglect, it is now the Firehouse Center for the Visual and Performing Arts. (Courtesy Lunt Collection.)

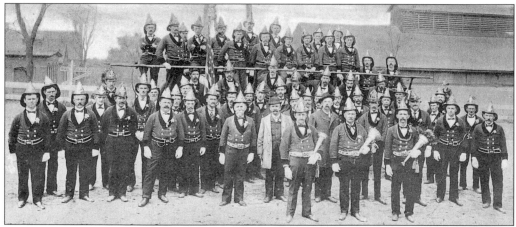

NEPTUNE VOLUNTEER FIREMEN, READY FOR A MUSTER (1899 POSTCARD PUBLISHED BY W.J. DWYER, NEW YORK). Named to honor the Roman god of the sea, whose symbolic water could douse fires in Newburyport, the men of this volunteer fire association located on Purchase Street stand proudly for a group photograph taken in Manchester, New Hampshire. The three elected officials in the foreground each cradle a silver or silver-plated fireman's trumpet engraved usually with the name of the fire company, a depiction of the apparatus, and important members' names and dates. In 1833, a committee was formed in the town to organize a fire department.

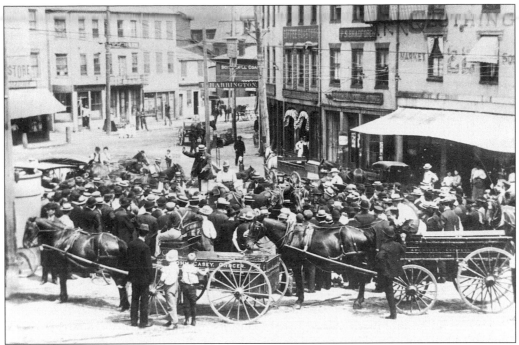

A POLITICAL RALLY IN MARKET SQUARE (C. 1900 PHOTOGRAPH). An unidentified politician appears to be making a very strong point in his speech for votes at a time when most men and boys wore a hat or cap in public. The Historical Society of Old Newbury owns the Thomas Hale's Hat Factory trade sign, with its whimsical topsy-turvy hats. Hale's hat factory was located in a building on his property in Belleville, before 1836. The Bailey Hat Factory on Merrimac Street, near the foot of Ashland Street, was large enough to be identified on an 1884 atlas map. (Courtesy Kulik Collection.)

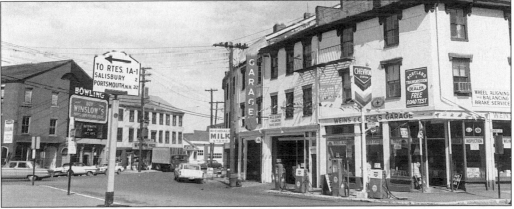

MARKET SQUARE BEFORE URBAN RENEWAL (C. 1965 PHOTOGRAPH BY BILL LANE). Before the Newburyport Redevelopment Authority began to implement its urban renewal plan, the downtown area had degenerated into a run-down, hodgepodge. The façades of many of the brick Federal period buildings had been altered and painted and had discordant signs. Local businesses, mainly Yankee-owned prior to the 1880s, were being replaced by some large chain stores and by shops opened by some of the newer members of the community, such as Bill Wein and Joe Checkoway's garage at the corner of Liberty Street and "Bossy" Gillis's gas station near the Central Fire Station.

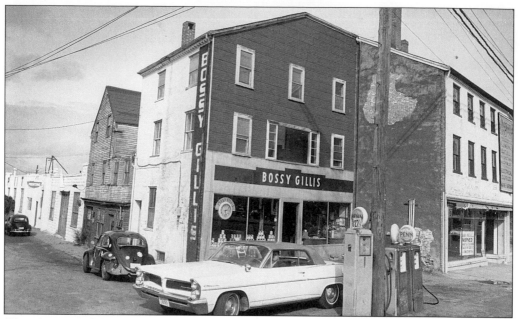

"Fill 'er up," Bossy Gillis's Gas Station, 3 Market Square (c. 1965 photograph by Bill Lane). The filling station owned by Andrew J. "Bossy" Gillis was located at the west end of the North Row from the late 1920s through the 1960s. Gillis, who was the city mayor, referred to his "no-charge oil company" as the "little city hall." During his last term as mayor, "Honest Andrew" dispensed gas and quips, such as calling the redevelopment project, which he vehemently opposed, "youban renewal."

"Bossy" Gillis at the Pump (c. 1960 photograph). Born, but not really "bred" in Newburyport, "Bossy" Gillis (1896–1965) was a red-haired, hot-tempered Irishman who had a tumultuous political career as an in-again, out-again mayor. He served six nonconsecutive terms, and he died two days after suffering a defeat in his 20th campaign for office. Gillis was an entrepreneur whose desire to set up a gasoline station on the corner of High and State Streets was really a way to get even with the latter-day "codfish aristocracy" residing on the fashionable elm-shaded street. Newspaper reporters and photographers covered the political career of the "bad-boy mayor," even while he was ironing clothes in the Salem House of Correction. (Private collection.)

Six

ALONG THE WATERFRONT

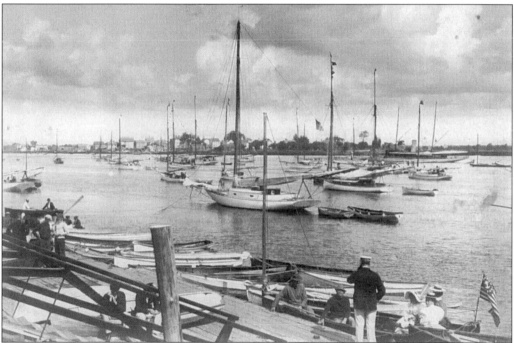

NEWBURYPORT YACHT CLUB WHARF, 117R WATER STREET (C. 1890s PHOTOGRAPH). A nautical interpretation of the Stars and Stripes flutters on the launch, which is about to take three well-to-do young women to one of the yachts on the busy river. The trio may be going for a cruise on the sleek *Ida J.* with the captain, who is giving instructions to the two men. The Merrimack River has been the lifeblood of Newburyport for centuries. Before the American Revolution, large three-masted vessels were built along the waterside and sold to the mother country. Later, such vessels were used as privateers against England during the War of 1812. The leviathans constructed during the late 19th century have been replaced by smaller craft, some fishing and lobster boats, and the ubiquitous whale-watch cruises that emanate from most picturesque New England seaports today. (Courtesy Laing Collection.)

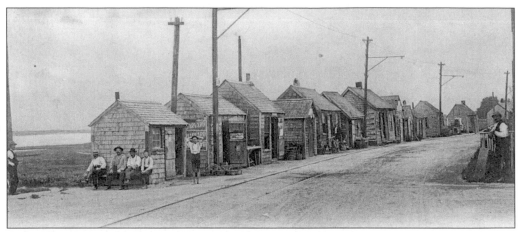

CLAM DIGGERS AND THEIR SHANTIES, "JOPPA" (1905 POSTCARD BY THE ROTOGRAPH COMPANY). The waterfront area along Water Street, somewhere between Somerby's Court and Rolfe's Lane, is known as Joppa Flats and has been referred to and pronounced by many locals as "Jopper" or "Joppy." A line of picturesque shingled shanties, or shacks, followed the curve in the road near Union Street at Flat Iron Point. They were used seasonally by clammers to store their equipment and perhaps to get a respite from family life.

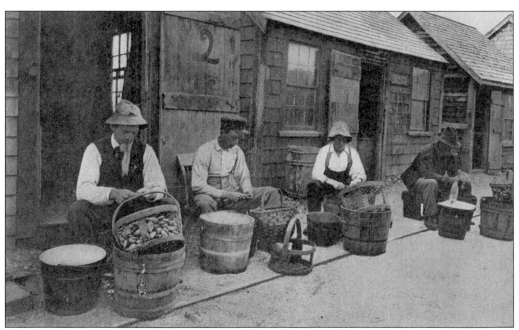

THE CLAM SHUCKERS (C. 1905 POSTCARD PUBLISHED BY THE G.W. ARMSTRONG D.R. & N. COMPANY, BOSTON). A circular wood-and-wire basket with a curved handle became the most popular form for toting clams in Joppa. Woven splint baskets were also used, but seawater drained more quickly from the former and provided better circulation for the temporary inhabitants. Busy at work, and with probably little to say to each other, are, from left to right, William H.H. Perkins, Clarence A. Bryant, Joseph Milton, and Arthur Simmons.

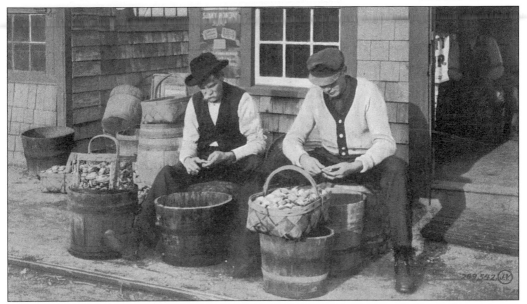

SHELLING CLAMS (C. 1911 POSTCARD PUBLISHED BY THE VALENTINE & SONS' PUBLISHING COMPANY). The shelling or shucking of clams is a tedious task, but one which provided extra seasonal income for such men as Amos Little and his son John. Prominent early Joppa area names were Hale and Woodwell, as exemplified by the 1781 marriage of Mary Woodwell to shipbuilder Enoch Hale, who founded the shipbuilding firm of Woodwell & Hale.

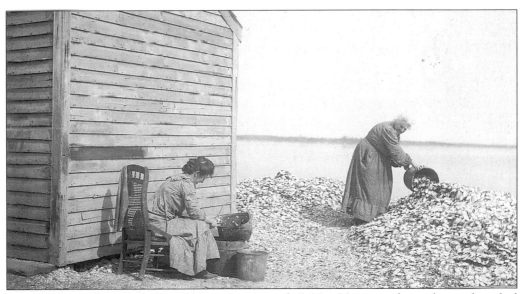

WOMEN CLAM SHUCKERS (C. 1895 PHOTOGRAPH.) A Mrs. Nason smiles at the unidentified photographer as she empties a bucket of shells on a growing mound, while her younger friend opens a bivalve mollusk while seated on a simple caned side chair. Women and children spent enjoyable time at the shanties visiting with the menfolk, and often, as shown here, helping with the work. Libby Russell, who resembled Mrs. Nason and who resided at 218 Water Street, shucked clams until her 80th birthday and sang in the Methodist church choir a few months prior to her death at the age of 87. (Courtesy Nason Collection.)

115

BEACH AT THE FOOT OF GOODWIN AVENUE OFF WATER STREET (C. 1925 PHOTOCARD). A large group of boys, some young men, and one girl enjoy a dip in the water on a hot summer afternoon. The dates '09 and 1914 appear as grafitti near the base of the large rock, a popular spot for sitting, changing one's clothes, or just enjoying the view. (Courtesy Lunt Collection.)

JOPPA LANDING, NEAR THE CORNER OF NEPTUNE STREET (EARLY-20TH-CENTURY POSTCARD PUBLISHED BY THE LEIGHTON COMPANY). The bony fish with a projecting snout, known as a sturgeon, was a profitable commodity for fishermen in Newbury during the mid- to late 17th century; pickled sturgeon was often exchanged for West India rum and molasses. "By hooke or crooke" was a term used by an aged fisherman in a Newbury court document. Mackerel fishing as an industry began c. 1800, and in 1833 a whaling company was formed along the waterside.

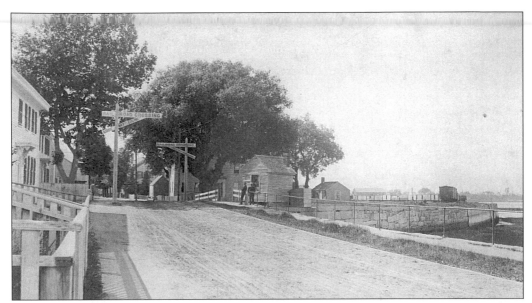

RAILROAD CROSSING ON WATER STREET (C. 1892 PHOTOGRAPH BY JOHN W. WINDER). A pair of tall, wooden railroad-crossing signs in the vicinity of Harrison Street admonish horse-drawn vehicle drivers, bicyclists, and pedestrians to be aware of slow-moving freight trains of the former City Railroad, such as the one making its way beside the granite retaining wall toward the wharves by the center of the city. (Courtesy Nason Collection.)

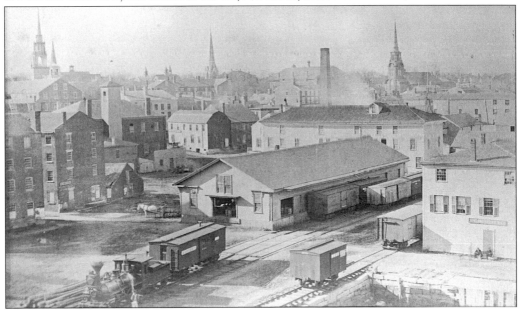

EASTERN RAILROAD COMPANY FREIGHT STATION, CITY WHARF (C. 1880 PHOTOGRAPH BY SELWYN C. REED). The Newburyport City Railroad Company laid out the rail bed and constructed the freight station on property that it leased to the Eastern Railroad Company in 1872. Twelve years later the Boston and Maine Railroad Company acquired these railway facilities. Prominent church steeples, from left to right, are the Unitarian church, the Harris Street Church, the Catholic church, and the Central Congregational Church. (Courtesy Schneider Collection.)

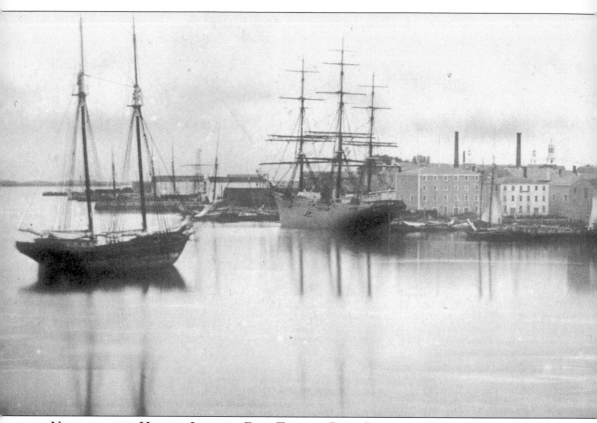

NEWBURYPORT HARBOR LOOKING EAST TOWARD PLUM ISLAND AND THE ATLANTIC OCEAN (C. 1865 PHOTOGRAPH). The first wharf to be built along the waterside was that constructed in 1655 by Capt. Paul White, somewhere in the vicinity of the wharves at the far right. Other early wharves, built to accommodate vessels engaged in the West India trade, included those owned by Abiel Somerby in 1731 and Benjamin Lunt in 1767, the latter being located at the foot of Marlboro Street. Eleazer Johnson, a shipbuilder and sea captain, ran a shipyard near the end of Federal Street during the period of the Revolutionary War. George Searle, a heraldic painter, was part owner of at least 14 vessels associated with Newburyport for the six-year period before his death in 1796. Maritime activity was at its apex locally until the time of "Mr. [Thomas] Jefferson's Embargo" of 1807; it then slowly revived, and a final burst of shipbuilding occurred during the late 19th century. The large hip-roofed wooden structure to the right of the *Sapphire* was located on Greenleaf's Wharf (later City Wharf), until it was razed between 1865 and 1872 for the construction of the Newburyport City Railway. That area is now the site of the attractive Waterfront Park Promenade, which was completed in 1978.

PHILADELPHIA & READING COAL & IRON COMPANY, 13 WATER STREET (C. 1880 PHOTOGRAPH BY SELWYN C. REED). As a heating fuel, coal came into general use c. 1832. By 1876, the large coal pocket for the storage and distribution of coal was ready to receive the black mineral chunks from such iron colliers, or coal ships, as the *Achilles, Centipede, Leopard,* and *Rattlesnake*. Safety was a big concern around the coal pocket with all of the daily activity, so it came as no surprise when a coal barge was sunk near the structure on January 11, 1908. The unsightly coal storage facility disappeared from the waterfront in the late 1920s due to a fire. (Private collection.)

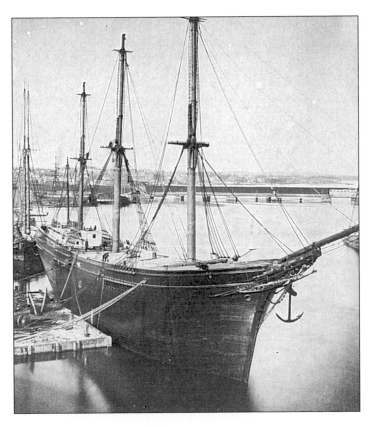

BARK *B.F. HUNT JR.* AT COMMERCIAL WHARF (C. 1882 PHOTOGRAPH). Immense, 19th-century three-masted vessels, either docked with their sections of sails furled or catching the wind as they headed toward the Atlantic, were a common but still exciting sight in the past. Built at the George E. Currier Shipyard on Merrimac Street at the foot of Ashland Street in 1881, the *Hunt* weighed 1,190 tons.

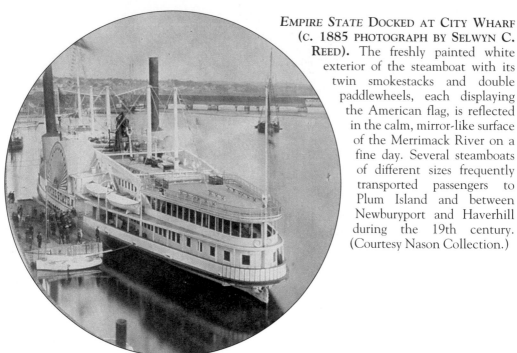

EMPIRE STATE DOCKED AT CITY WHARF (C. 1885 PHOTOGRAPH BY SELWYN C. REED). The freshly painted white exterior of the steamboat with its twin smokestacks and double paddlewheels, each displaying the American flag, is reflected in the calm, mirror-like surface of the Merrimack River on a fine day. Several steamboats of different sizes frequently transported passengers to Plum Island and between Newburyport and Haverhill during the 19th century. (Courtesy Nason Collection.)

SHIP DANIEL I. TENNEY, BUILT AT THE JOHN CURRIER JR. SHIPYARD, MERRIMAC STREET (1875 PHOTOGRAPH). The 1,686-ton *Tenney* was the 91st vessel to be constructed at the busiest Newburyport shipyard during the 19th century. The carved and painted figurehead of Daniel I. Tenney, a New York City philanthropist who financially remembered his hometown, now has a place of honor in a Nantucket garden. During the centennial year of America's independence, 28 ships, 26 brigs, 145 schooners, 4 barks, and 4 sloops were registered in the district of Newburyport. (Courtesy Nason Collection.)

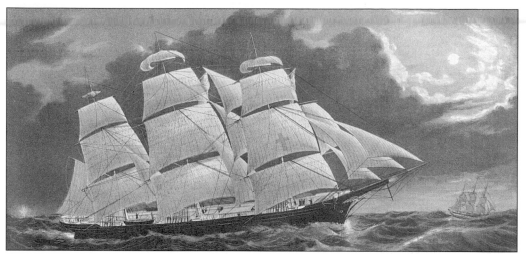

CLIPPER SHIP *DREADNOUGHT* OFF TUSKAR LIGHT (1856 LITHOGRAPH BY NATHANIEL CURRIER). This dramatic rendition of the famous clipper ship was issued as a large folio print one year before the name of James Merritt Ives began to appear on Currier & Ives imprints. Launched in 1853 from the shipyard of William Currier and James L. Townsend at the foot of Ashland Street, the *Dreadnought* made a celebrated passage from New York to Liverpool, England, in 13 days and 11 hours in December 1854. A commemorative plaque set in a boulder on Merrimac Street at the foot of Ashland Street chronicles the history of the *Dreadnought*. (Courtesy Stephen J. Schier.)

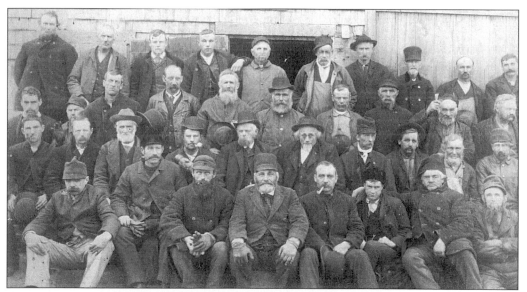

EMPLOYEES AT GEORGE E. CURRIER'S SHIPYARD ON MERRIMAC STREET AT THE FOOT OF ASHLAND STREET (1890 PHOTOGRAPH). Taking a break during the construction of the *Clarence H. Venner*, 38 men of various ages and backgrounds pose in cold-weather garb in front of the shingled warehouse called the Red Shed. Frank L. Dunning, the head foreman, is seated in the first row, fourth from the left. Another shipbuilder, Gideon Woodwell, offered "a treat for his carpenters" by serving lunch when a vessel was launched—the cheese and crackers were enjoyed by the hearty men, but they would have preferred to wash it down with grog instead of the lemonade usually offered. (Private collection.)

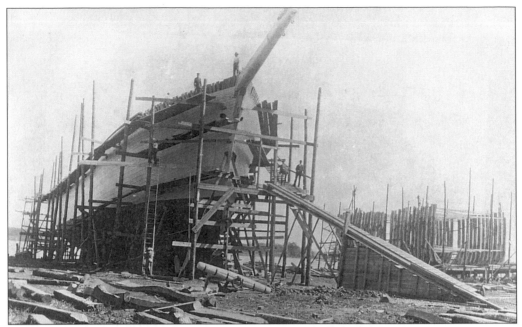

CONSTRUCTION OF THE SHIPS *EDITH H. SYMINGTON* AND *HORACE W. MACOMBER* AT
GEORGE E. CURRIER'S SHIPYARD ON MERRIMAC STREET AT THE FOOT OF ASHLAND STREET
(1890 PHOTOGRAPH). The construction of a vessel from the ground up takes a lot of
land, much timber, the talent of the designer, and the skill of the workmen—one of whom
poses jauntily on the platform near the prow. The ark-like *Symington*, built for a New York
mercantile firm, has taken shape, whereas the *Macomber* has only half a hull formed. (Courtesy
Nason Collection.)

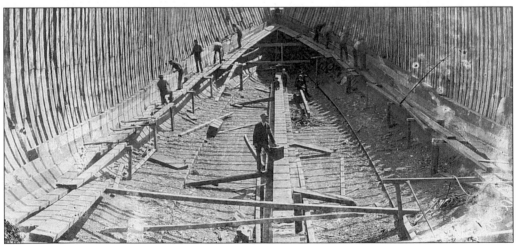

HULL CONSTRUCTION OF THE *HORACE W. MACOMBER* (1890 PHOTOGRAPH). Being inside
the leviathan-like skeleton of a vessel as large as the *Macomber* may have prompted many a
God-fearing workman to ponder the Biblical story of Jonah and the whale. Orlando B. Merrill
built over 60 vessels at his shipyard in the North End, including the *Pickering* in 1798 and the
sloop *Wasp* in 1813. He is believed to have invented the first waterline model—a half-hull
wood model, built in horizontal sections that can be added to or deleted from when designing a
vessel—in 1794, when in his nineties. (Courtesy Nason Collection.)

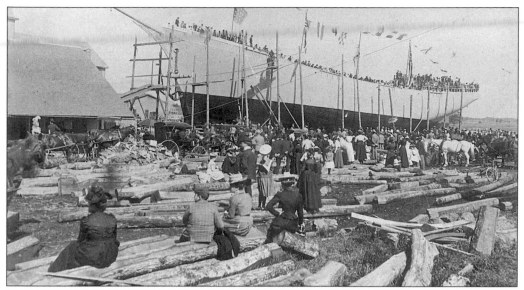

LAUNCHING OF THE *EDITH H. SYMINGTON*, GEORGE E. CURRIER'S SHIPYARD, MERRIMAC STREET AT THE FOOT OF ASHLAND STREET (1890 PHOTOGRAPH). Flags and pennants swirled in the breeze on the sunny day when the *Symington* was cut loose to slide down the ways in the presence of the owners and other well-dressed spectators. Between 1831, when the ship *Brenda* (375 tons) was built at John Currier Jr.'s shipyard on Merrimac Court, and 1883, when the last of the Newburyport square-riggers, the *Mary L. Cushing* (1,575 tons), was built, a noteworthy 317 vessels were constructed by various shipbuilding firms along Merrimac Street, according to late-19th-century local historian John H. Currier. (Courtesy Mercedes Ames.)

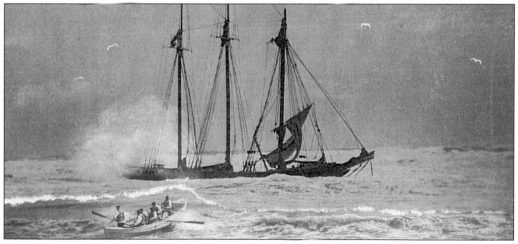

WRECK OF THE *JENNIE M. CARTER* (APRIL 13, 1894 PHOTOGRAPH). The *Jennie M. Carter*, a three-masted schooner out of Providence, Rhode Island, was carrying a cargo of heavy stone when she foundered near the mouth of the Merrimack River. The most famous local shipwreck of the 19th century occurred on Christmas Eve of 1839 when the *Pocahontas* was wrecked off Plum Island. Nine bodies, including those of Capt. James G. Cook and chief mate Albert Cook, were recovered and given proper burials. A simple marble monument was erected in the Old Hill Burial Ground for seven foreign-born crewmen, not interred with the captain and chief mate. The salvaged bell from the *Pocahontas* is in the collection of the Historical Society of Old Newbury.

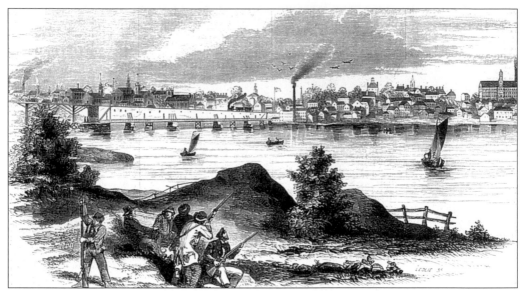

VIEW OF THE CITY . . . FROM SALISBURY (1852 ENGRAVING IN GLEASON'S PICTORIAL DRAWING ROOM COMPANION). A bevy of hatted hunters take aim, reload, and wait for another flock of fowl to fly over their chosen spot on the Salisbury shore. The second bridge between Newburyport and Salisbury was erected beginning in 1840 to replace the first one built on four stone piers in 1827 by the Eastern Railroad Company. Carts, carriages, and pedestrians used the lower of the two roadbeds, and trains—such as the one bellowing smoke in competition with a nearby factory smokestack—traveled on the upper level.

CONSTRUCTION WORKERS BY THE NEWBURYPORT AND SALISBURY BRIDGE (C. 1895 PHOTOGRAPH). Rugged workmen stop their pipe laying for this picture, which shows the new iron drawbridge erected in 1875. The old bridge had been a toll road until 1868, when it became a public highway. (Private collection.)

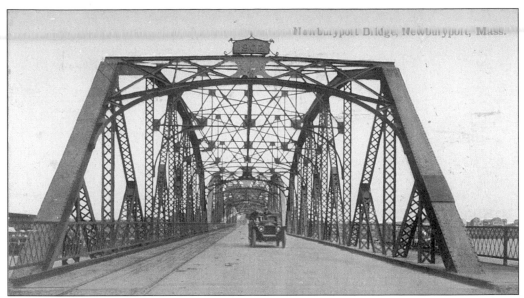

NEWBURYPORT BRIDGE (C. 1910 POSTCARD PUBLISHED BY THE VALENTINE & SONS PUBLISHING COMPANY). A "tin lizzie" makes its way over the new steel bridge from quaint Ring's Island in Salisbury. Built in 1902, the bridge had a sign stating that "All persons are forbidden by law to ride or drive any horse over this bridge faster than a walk under penalty of one dollar."

DEER ISLAND FROM MOULTON HILL (C. 1895 PHOTOGRAPH). The slightly arched, shingled-covered wooden bridge at the left was erected by Timothy Palmer in 1792 with a "Letters Patent . . . for a new improvement in the construction of Timber Bridges, on a more extensive plan than any known either in Europe or America." Both this bridge with its extension connecting Deer Island to the Amesbury shore and the Essex-Merrimack, or "Chain Bridge," connecting the island to the Newburyport shore, have beguiled locals and tourists for many generations. (Private collection.)

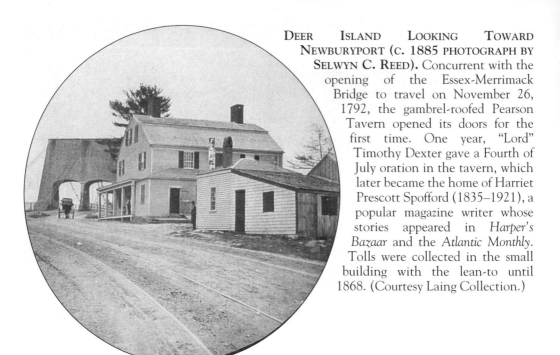

DEER ISLAND LOOKING TOWARD NEWBURYPORT (C. 1885 PHOTOGRAPH BY SELWYN C. REED). Concurrent with the opening of the Essex-Merrimack Bridge to travel on November 26, 1792, the gambrel-roofed Pearson Tavern opened its doors for the first time. One year, "Lord" Timothy Dexter gave a Fourth of July oration in the tavern, which later became the home of Harriet Prescott Spofford (1835–1921), a popular magazine writer whose stories appeared in *Harper's Bazaar* and the *Atlantic Monthly*. Tolls were collected in the small building with the lean-to until 1868. (Courtesy Laing Collection.)

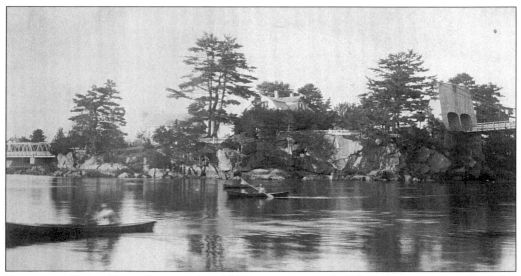

PADDLING PAST DEER ISLAND (C. 1895 PHOTOGRAPH). The action, or speed, of the photographer's camera could not stop the motion of the three men enjoying an afternoon's row on the Merrimack River. Several people watch them from Harriet Prescott Spofford's rustic summer house in Amesbury, reached via a long walkway with a protective fence. (Courtesy Haverhill Public Library.)

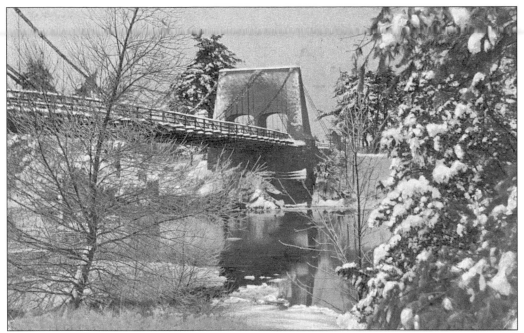

WINTER SCENE, "CHAIN BRIDGE" (C. 1909 POSTCARD PUBLISHED BY THE LEIGHTON COMPANY). One of the most popular local postcards issued during the early 20th century is this snowy scene showing the "Chain Bridge" reflected in the Merrimack River. Coincidentally addressed to a "Mrs. Snowdon," the sender wrote that "We had to go under this bridge to get to Haverhill."

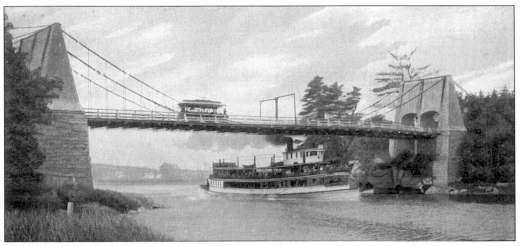

"CHAIN BRIDGE" (EARLY-20TH-CENTURY POSTCARD PUBLISHED BY THE LEIGHTON COMPANY). People who rode in trolleys over the bridge or in vessels under the bridge favored these modes of transportation around the turn of the century. Ferry service in the area began as early as 1687, and steamboat excursions started during the summer of 1835; the trolley spanned the last decades of the 19th century and the first decades of the 20th century. What delightful ways in the past to savor the charms of "Dear Old Newburyport."

BIBLIOGRAPHY

Barber, John Warner. *Historical Collections of Every Town in Massachusetts*. Worcester, MA: Dorr, _____ Howland & Co., 1839.

Benes, Peter. *Old-Town and the Waterside*. Newburyport, MA: Historical Society of Old Newbury, 1986.

Currier, John J. *History of Newburyport, Mass., 1764–1905*. Newburyport, MA: Author, 1906.

_____. *History of Newburyport, Mass., 1764–1909*. Newburyport, MA: Author, 1909.

Cushing, Caleb. *The History and Present State of Newburyport*. Newburyport, MA: B.W. Allen, 1826.

Emery, Sarah Anna. *Reminiscences of a Nonagenarian*. Newburyport, MA: Huse, 1879.

Hale, Albert. *Old Newburyport Houses*. Boston: Clarke, 1912.

Howells, John Mead. *The Architectural Heritage of the Merrimack*. New York: Architectural Book, 1941.

Jacobs, Peter H. *Front and Center: The Legend of Bossy Gillis*. Newbury, MA: Newburyport Press Inc., 1969.

Junior League of Boston Inc. *Along the Coast of Essex County*. Boston: Junior League of Boston Inc., 1970.

Images from the Past, 1635–1985, Newbury, Massachusetts. Newbury, MA: 1985.

Polito, Ronald. *A Directory of Massachusetts Photographers*. Camden, ME: Picton Press, 1993.

Smith, Mrs. E. Vale. *History of Newburyport*. Boston: Damrell and Moore, 1854.

Warner, W. Lloyd, et al. *Yankee City*. New Haven, CT: Yale University Press, 1963.

Weare, Nancy V. *Plum Island, The Way It Was*. Newbury, MA: Newburyport Press Inc., 1993.

Wood, Vincent L. *Plum Island Recollections*. Newbury, MA: Newburyport Press Inc., 1995.

Wright, John Hardy. *Vernacular Visions: Folk Art of Old Newbury*. Newburyport, MA: Historical Society of Old Newbury, 1994.

City directories and maps for Newbury and Newburyport.

The Cheney Collection from the Custom House Maritime Museum. Newbury, MA: Newburyport Press Inc., 1992.

Through the Lens, Early Newburyport Photographers & Photographs, 1839 to 1900. Newburyport, MA: The Journey Press, 1990.